N ENGLAND

n

Tatham

WINSLOW HOMER IN ENGLAND

© Tony Harrison 1983 (Revised 1995, 2004)

Introduction © David Tatham 2004

A. Adamson Essay © Linda Greenley 1983

ISBN 0-9636414-2-5 (hardcover)
ISBN 0-9636414-3-3 (softcover)

Printed by Capital Offset Company Inc., Concord, NH, USA

Published by Hornby Editions
PO Box 7099, Ocean Park, Maine, 04063-7099, USA

(This volume is a revised and enlarged version of "Winslow Homer in Cullercoats" published in the U.K. in 1995 by Station Press)

Front Cover: "Fisher Girl with Net" - 1882 by Winslow Homer
© Sterling & Francine Clark Art Institute, Williamstown, Massachusetts

Back Cover: "An Afterglow" - 1883 by Winslow Homer
© Museum of Fine Arts, Boston, Massachusetts

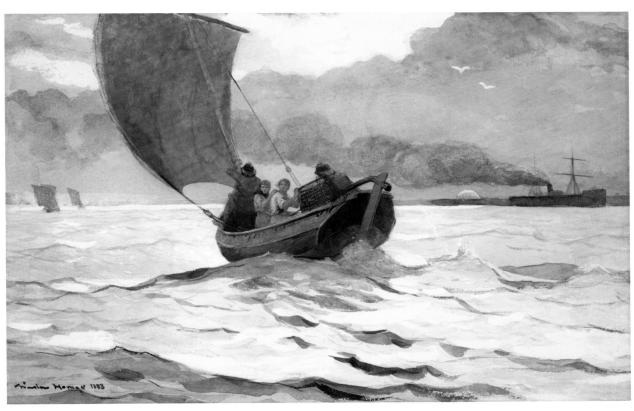

"Returning Fishing Boats"
also known as "Tynemouth" - 1883 by Winslow Homer
© *Fogg Art Museum, Harvard University, Cambridge, Massachusetts.*

This book is dedicated to the memory of John and Mollie Boon.

P.R. Hornby wishes to honor the memory of his grandmother, Phoebe Hotchkiss, whose love of Winslow Homer's work inspired him as an artist.

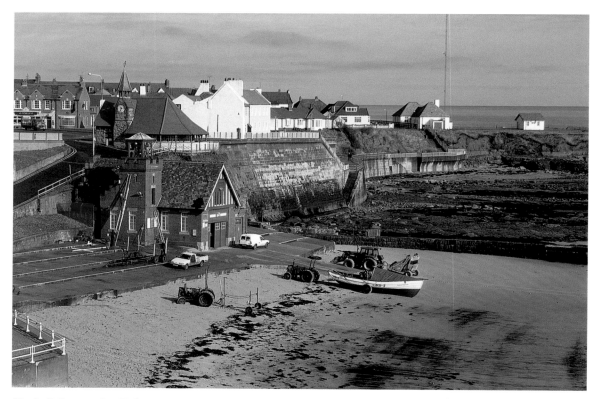

Fig. 1. Cullercoats Bay Today
Photo by Peter R. Hornby

PREFACE

In March 1881, Winslow Homer, already well established as one of the foremost American artists of his time, travelled to England in search of new subjects for his brush. He found his way to the small, remote, wind swept fishing village of Cullercoats in Northumberland on the North East coast of England where he lived for a year and a half, making numerous sketches, drawings, watercolours and oil paintings. He was ten miles from the large city of Newcastle upon Tyne, and about two miles from the fashionable Victorian resort of Tynemouth.

Although much has been written about Homer for more than a century, only in recent years have serious, detailed studies begun to examine Homer's English sojourn. Most active in this field was the late John Boon, a local historian and resident of Tynemouth. Without John Boon's help, advice, and encouragement, I would not have progressed far with this volume. His diligent research and enthusiasm prompted me to organize and stage, with the help of the members of the Cullercoats Local History Society, an exhibition in June 1981 in celebration of the Centenary of Homer's arrival in Cullercoats. The exhibition consisted of photographs of many of Homer's English works kindly provided by several American museums and galleries, together with a selection of colour reproductions of some of his best-known paintings. Also on view were many original paintings by some of Homer's Cullercoats contemporaries including Robert Jobling, Henry Hetherington Emmerson, George Horton, John Charlton and Bernard Benedict Hemy. Those works of art were augmented by many photographs of Cullercoats and its fisherfolk, some being on public display for the first time.

The exhibition attracted extensive coverage by the media and was such a thoroughgoing success that the preparation of a book specifically devoted to Homer's English sojourn seemed to be in order. New avenues of research suggested by the exhibition were followed up and many proved to be fruitful. Perhaps the most important discovery was the Adamson Manuscript. During her visit to the 1981 exhibition, Linda Greenley, a resident of Cullercoats, told me that a friend, Dorothy Mitchell had told her that her uncle, Alan Adamson had become friendly with Homer during his stay in Cullercoats and had returned to the United States with him in 1882. Dorothy Mitchell had died some years earlier, but Linda Greenley had the address of a cousin. I suggested that she write to this cousin, John Bulcock, and he confirmed that his uncle, Alan Adamson had emigrated to the United States in 1882. He also furnished us with the name and address of Alan Adamson's daughter Constance Overesch, who lived in Michigan. Linda Greenley entered into a correspondence with Constance, who was interested to hear of my book project and provided us with some useful information. Then following the death of her elder brother, Constance discovered some Homer memorabilia, including the essay, amongst his possessions and forwarded the items to us for publication in this book. The essay by Alan Adamson, is published in full along with some of the other items that were sent to us by Constance Overesch.

The aim of this book is to present a historically accurate account of Homer's stay in Cullercoats. I do not pretend to treat his art critically, though in presenting the most complete list of Homer's English works ever published in one volume, I have taken the opportunity to correct erroneous information that has reached print over the past century.

The preparation of this study has been a labour of love. I hope that my readers will gain at least as much enjoyment from reading it as I have had in writing it.

Tony Harrison

INTRODUCTION

In March 1881, at age forty-five, the American artist Winslow Homer sailed from New York to Liverpool. He had not been to England before, and no record of his travels within the country survives. It seems likely, however, that after disembarking at the busy port he headed by rail directly to the great metropolis of London. He found time there, then or later in the year, to paint a remarkably atmospheric watercolor of the Houses of Parliament from the south bank of the Thames, a work that preceded Monet's similarly light-infused treatments of the same subject by two decades. At some point he journeyed northward more than half the length of the country to the North Sea fishing village of Cullercoats, near Tynemouth. By design or otherwise, this small marine community became his home for a year and a half.

Homer's career was then at mid-point. He had started as an illustrator, appearing as early as 1857 in the pages of *Harper's Weekly* and other pictorial magazines. When he began to exhibit oil paintings in the mid-1860's, critics found much to admire in them. In most of these early oils, his subjects concerned the American Civil War. Then, with the end of hostilities in 1865, he turned to scenes of America at peace. From the late 1860's through the 1870's he depicted impeccably attired young adults at seaside and mountain resorts, carefree children at play in the countryside, emancipated African-Americans in rural Virginia, and sturdy trappers, sportsmen, and guides in the Adirondack wilderness of northern New York State. In nearly all these subjects he presented the natural world as a calm, sunny, and beneficent place.

When Homer sailed for England in 1881, critics and others who knew him must have assumed that he was taking a working holiday. They had no reason to suppose that he would remain in England for a year and a half or that this sojourn abroad would alter his style, recast his subjects, and instill in his work a wholly new understanding of nature. There had been, after all, little change in his work when he returned from his only other crossing of the Atlantic. That had occurred in 1866-67 when he spent ten months in France. He had gone there to learn something of the art and culture of Paris, to bask in the attention given two of his Civil War canvases at the Exposition Universelle, and to paint.

But his time in England was different. Rather than residing in a major center of culture, he lived in a small fishing village. Instead of associating with other Americans abroad, as he had in Paris, he made himself part of a community of local fisherfolk. The experience proved to be of crucial importance to his development. Soon after his return to New York in November 1882, critics recognized that his work had gained a new, even stronger voice. Cullercoats had acted as a catalyst, releasing newfound powers of expression. All his old strengths were still in evidence: his masterful sense of form, directness of statement, distinctive draughtsmanship, avoidance of needless detail, and quite remarkable ability to elevate ordinary things into memorable images. His style had always been unique, the product of a largely self-taught artist whose untutored eloquence was a testimony to Emersonian self-reliance. Now it gained new strengths.

Homer's brushwork became more fluent, his typical largeness of concept grew larger still, and a more intense quality of drama came to the fore. His work took on a Darwinian cast as he increasingly portrayed the natural world as a place of struggle for survival in ever-changing environments. Inspired by the Cullercoats fisherfolk in their contest with the sea, his oil paintings of the 1880's took on a dark mood; one more somber than those of his benign, often lyrical subjects of the 1870's. Gone was the sense of summer freshness and well-being so evident in many of those earlier works. Action and narrative, which had been subdued in most of his post-Civil War paintings, returned to prominence.

The watercolors Homer painted in Cullercoats in 1881 - 1882 stand alone as a group. They contain a distinctive cold gray light and, more importantly, a warm sense of human association. Gone are the self-possessed men and women of his earlier works – still, silent, untouching, and reserved in feeling. The Cullercoats figures (who are mostly women) converse, touch, work together, and convey an unmistakable sense of close-knit community. The psychological and physical engagement of these women, with the world around them, is a kind rarely seen in Homer's American women. These fishwives watch the sea intently and anxiously, talk and banter with each other, stride purposefully, and carry creels and children. They mend nets and bait lines. Only in his paintings of African-American cotton pickers of the 1870's had Homer shown women involved in manual labor, but those figures appear posed and restrained compared to the greater naturalism of his Cullercoats fishwives.

He heightened the intrinsic drama of the everyday life of the Cullercoats women by silhouetting them against the sky, and cliffs, and by sometimes massing them together to withstand a threatening natural world. When he depicted them in peaceful moments of rare leisure in cool northern sunlight, he nearly always included details that speak of labors yet to be done. Homer's admiration and affection for these women suffuses his drawings and paintings of 1881 and 1882, giving them an understructure of emotion rare in his life's work.

Though there is much human action and feeling in these paintings, another presence is evident, though not always visible: the sea. Directly or indirectly, it controlled nearly everything in Cullercoats. The sea Homer had painted at ocean-side resorts in America was essentially a decorative element in his genre subjects, just as in life it was primarily of only recreational interest to tourists. But in Cullercoats, Homer conveyed a new understanding: that the sea was an elemental force that impacted lives from birth to death. In this small fishing village he began to paint the human figure as an intrinsic part of a dynamic natural world.

In 1883, settled again for a while in New York before moving permanently to a studio-home overlooking the Atlantic in Maine, Homer sent a number of his English works to exhibitions where they met critical praise. Perhaps the best measure of how important these works seemed at the time is found in an admiring review by Mariana Griswold Van Rensselaer, the most perceptive American art critic of her time. Her essay appeared in the November 1883 number of *Century* magazine. (In 1889, she included a revision of the article in her book *Six Portraits*.) Calling the watercolors he exhibited at the American Watercolor Society "the most complete and beautiful things he has yet produced." She then wrote, "In all the underlying essentials which go to make a man an artist, as distinguished from a painter merely, his success has been complete. There are few men alive who can be counted as his peers in vigor of idea or clearness of conception, in the application of these ends to painter-like ends... He can impress the mind, move the heart, stir the imagination by his pictures; at the same time he can satisfy the eye with their veracity and delight it with their magnificent effects of line."

Van Rensselaer supposed that Homer's career had culminated with his Cullercoats watercolors. Yet these works heralded even greater accomplishments in the years ahead. In the next quarter of a century, Homer would produce a long sequence of masterworks in oil and watercolor, nearly all of which in one way or another reflected the maturing influence of a year and a half spent in a fishing village on the North Sea.

David Tatham, Syracuse University

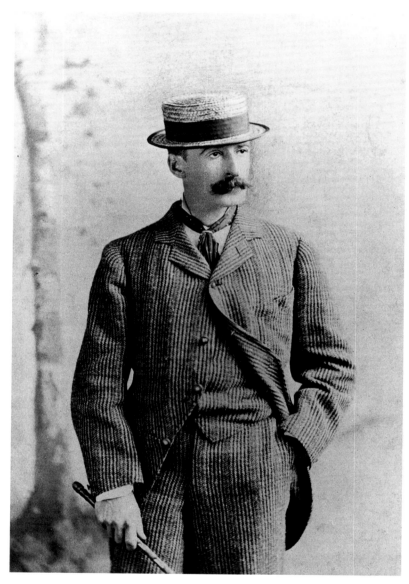

Fig 2. Winslow Homer, ca. 1880
by Napoleon Sarony
© *Bowdoin College Museum of Art*
Brunswick, Maine

CONTENTS

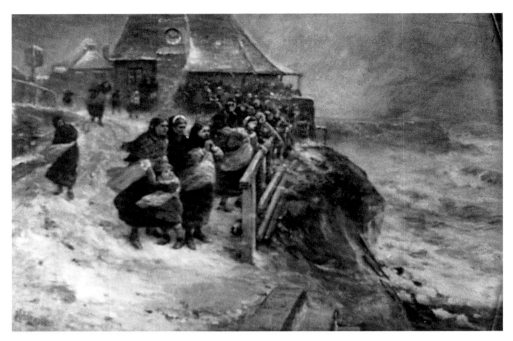

Fig 3. A Stormy Day in Cullercoats

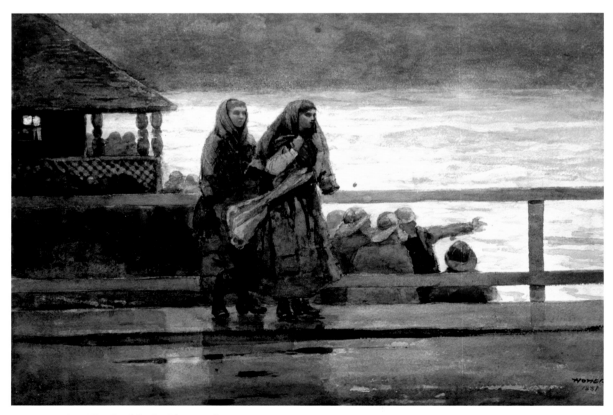

Fig 4. "Perils of the Sea" by Winslow Homer
© Sterling and Francine Clark Art Institute,
Williamstown, Massachusetts

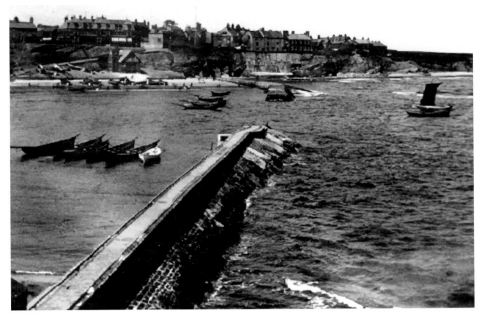

Fig 5. Cullercoats Bay, ca. 1900,
much as it would have looked when
Winslow Homer arrived in 1881

WINSLOW HOMER: A BRIEF BIOGRAPHY

Winslow Homer was a New Englander by birth and long ancestry. About 1636, Captain John Homer, an Englishman living in the west of England and active in maritime shipping, emigrated to America. He settled in Massachusetts where, almost two centuries later his descendant Winslow Homer was born in Boston on February 24, 1836. Winslow grew up in the nearby village of Cambridge, a short walk from Harvard University. His mother was, like his father, of old New England Yankee stock and he undoubtedly inherited her artistic talent. She was a skilful amateur watercolourist. She encouraged him when, as a child he showed an aptitude for drawing.

At about the age of eighteen, Homer became apprenticed to a Boston lithographer, John H. Bufford in whose shop he was trained to copy other people's drawings onto printing stones. He soon grew tired of this and, at age twenty-one, set himself up as a freelance illustrator. Much of his work was published in the newly popular pictorial weeklies including *Harper's Weekly*, one of the most popular magazines of the day. Homer's subjects in these illustrations were nearly always the life he observed around him in city and country. He drew his illustrations on wood blocks which were then engraved by others following the usual practice of the time.

In 1859, he moved from Boston to New York to be closer to the *Harper's* office and also because he was now determined to become a painter. New York was the centre of the American art world. He took a few lessons at the National Academy but soon discontinued them, apparently finding them of little value. At the outbreak of the American Civil War in 1861, Homer began to report scenes of military life. He went to the war front in Virginia for a period in 1862 and from this experience came his earliest paintings.

In 1866, he made the first of his two trips abroad, spending ten months in France. During this time he painted in Paris and its environs. Two of his paintings of the American Civil War were on exhibition in the art section of the Exposition Universelle in 1867. After his stay in Paris, he returned to New York where, in 1873, he began painting in watercolour as well as oil. Within a decade he had become the great American master of the medium.

He ceased working as a popular illustrator in the mid-1870's. By that time he was widely regarded as one of the most able and original American artists of his generation. His work was always well received by critics but it sold only moderately well.

As a person, Homer was reserved and taciturn. With the passage of years, he cared less for city life and its social involvements. Always independent, from mid-life onward he increasingly sought a more isolated existence. He never married.

In the spring of 1881, at age forty-five, Homer made his second voyage abroad. He settled in the fishing village of Cullercoats on the North East coast of England, where he stayed for eighteen months. He made numerous drawings, many watercolours and a few oils. He took as his subjects the sea, the coast, the fishing boats and most of all the fishwives who worked in and around the village while their men were away at sea. One of his Cullercoats works, the oil painting, *Hark! The Lark*, was included in the summer exhibition of the Royal Academy of Arts in London in 1882.

On his return to America late in 1882, he closed his New York studio and moved to Prout's Neck on the coast of Maine, a rock-bound peninsula a few miles south of the city of Portland. Prout's Neck was inhabited for most of the year mainly by local fishermen and their families and in many ways it was a place similar to Cullercoats. In July and August, well-to-do summer residents including Homer's parents, brothers, and sisters-in-law, swelled the population. For the rest of his life, Homer resided in a studio-cottage overlooking the sea. He painted many of his major oils there between 1884 and 1910, the year of his death.

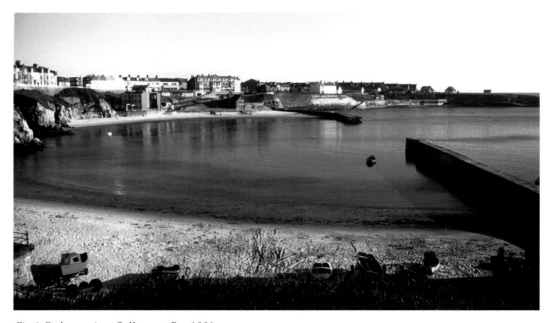

Fig 6. Early evening, Cullercoats Bay 1981

Beginning in the mid-1880's, Homer escaped the rigorous Prout's Neck winters by fishing and painting in such warmer and sunnier sub-tropical places as Cuba, the Bahamas, and Florida. From these visits came a series of brilliant watercolours. They were rivaled only by those he executed in the Adirondacks during his summer fishing trips to that region of Northern New York State in the late 1880's and 1890's. His reputation as a major American master rose steadily throughout these years. His paintings sold reasonably well, though without the high prices earned by such international favorites as John Singer Sargent. In his later years, after about 1900, Homer was generally regarded as the foremost living American painter. He died in his studio-cottage at Prout's Neck on 29 September 1910 at age 74.

INDUSTRIAL CULLERCOATS

High on the cliffs overlooking the North Sea, about two miles north of the river Tyne, stands the village of Cullercoats. The adjacent towns of Tynemouth to the south and Whitley Bay to the north have in recent years pressed closer and closer until it almost seems that the old village of Cullercoats will be pushed into the sea. But although the cottages and narrow streets and alleyways with their quaint customs and fisherfolk are now nearly all gone, Cullercoats remains a clearly defined place with its crescent shaped beach virtually as it was in Homer's time. What remains of the village clings to the edge of the cliff above the beach with the tenacity of a limpet to a rock as if trying to ignore its neighbours. To a remarkable degree the village has managed to preserve a record of the ways of life that made it a famous place in England for a century.

The name Cullercoats, which has been spelled in at least fifteen different ways during the past three hundred years, was first recorded as Culfre-cots in the early seventeenth century. "Culfer" is an Anglo-Saxon word meaning dove and "cots" is plural for house, so the name translates as Dove Houses or Dove Cotes. Since the Priors of Tynemouth, (who owned land at Cullercoats) kept pigeons for their table, it is possible that they originated the village's name. Another possibility is that the name came from the Dove family which has been prominent in Cullercoats since 1539. In 1682, Thomas Dove Jr. built a mansion house of goodly proportions for the time, though quite modest in size by later standards. This edifice was named "Dove Cottage." Eventually it became known locally as "Sparrow Hall" (or "Sparra Haarl" in the local tongue). Traditionally, this change of name has been explained by the fact that the villagers believed that the carved representation of a bird on the front and back door lintels of the building looked more like a sparrow than a dove. During its long and varied history, Dove cottage underwent many modifications. Although Homer knew it well, he only included it in one of his paintings. The building was continuously inhabited until its demolition in the spring of 1979.

Fig 7. The Apex Stone of Dove Cottage. The Initials stand for Thomas Dove and Eleanor Dove

Figs 8 & 9. Dove Cottage (or "Sparra Haarl") in the 1880's

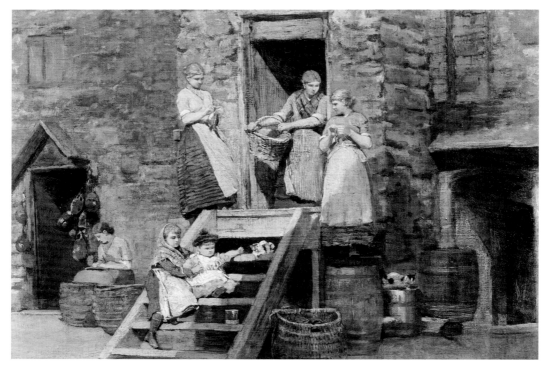

Fig 10. "Sparrow Hall, Cullercoats"
by Winslow Homer
Private Collection

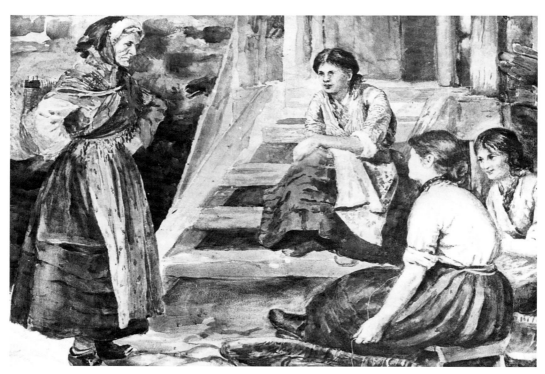

Fig 11. "Dove Cottage, Cullercoats"
by Isa Jobling
Private Collection

Before the suppression of Tynemouth Priory in 1539 by Henry VIII, the land now occupied by Cullercoats village appears to have been without any established settlement. Nearly a century later, in 1621, when Thomas Dove Sr. became owner of the land, it contained little more than a few houses and a thirteenth century water mill near the mouth of the Marden Burn (very near the site of the present day Fisherman's Mission at the corner of Eskdale Terrace). In 1676, John Dove Jr. devised a scheme for developing the mineral resources of the district. In partnership with John Carr of Newcastle upon Tyne, he sank and worked coal pits at Monkseaton and Whitley. He laid a wagonway from the pits to Cullercoats where he built staiths and coal spouts and erected a pier.

Much of the coal mined at this time was of too poor a quality to be shipped, so rather than throw it away, the mine owners sold it to the salt makers of the region. Until the advent of modern methods of food preservation by canning and freezing, large quantities of salt were required to preserve meat, fish, and vegetables for the winter. Salt was also needed in agriculture and other trades. It was so precious a commodity in country districts that some houses had secret salt "hides" built into their walls. The main method of salt manufacture at the time was to boil down sea-water in large open pans. The Tynemouth priors had introduced this method to the region much earlier. Their use of salt pans on the river Tyne was recorded as early as 1462.

The pans used for salt making were made of lead and originally heated by wood fires, but when the wood became scarce, coal took over its place. Coal fires caused the lead pans to corrode however, and so the salt-makers on the river Tyne began to use cast iron pans late in the fifteenth century. The cheap, low grade coal used for salt-making was known as "pan coal." It became customary to lease pit and pans together.

John Dove Jr. saw the obvious advantages to this arrangement when he built his wagonway. He leased land on the Bank Top overlooking Cullercoats harbour to a salt merchant of South Shields allowing him to erect two salt pans with all the other buildings necessary to carry on the business. This included houses for the garners (storemen) and salters, and the liberty to export salt from the quay, all this for the sum of 12 pence per year. By 1690, there were seventeen pans in Cullercoats (seven on the north side of the bay and ten on the south side above the Smuggler's Cave). Not all of the salt was shipped from the quayside. Some went by pack-horse into the countryside along well recognized routes known as Salt Trods. Many place names in the region record this: for example, Salter's Road and Salter's Bridge in Gosforth, and Salter's Gate in Alnwick.

Some salt was smuggled in from Scotland. The Smuggler's Cave at the south east extreme of Cullercoats Bay is a reminder that in the early Dove generations, smuggling was a serious business as well as a popular industry along the coast. Those engaged in it were regarded as benefactors to the village community. Smuggling lore was still common talk when Homer visited Cullercoats. It was a subject for painters seeking historical subjects. In 1970, a visible reminder of the "trade" appeared when during construction of the sea wall just south of Cliff House, a tunnel was uncovered in the side of the cliff. It travelled twenty-five yards west to terminate below the site of Dial House.

Salt making established Cullercoats as a place of some importance in the North East. But however important the salt trade and smuggling may have been to the early history of the village, nearly anyone in present day Cullercoats, when asked to name the commodity which made the village flourish and brought it fame would answer: fish.

The Cullercoats fishing industry was at its peak when Homer found his way there in 1881. It had come into being about a century earlier. The fishing fleet, which at the time of Homer's visit numbered around 130 vessels, consisted of well tested, sturdy seaworthy

boats called cobles. The boat's name probably comes from the word "couples," a much earlier type of boat which is mentioned in the Lindisfarne Gospels. The word is pronounced with a long "o" as in "cobalt."

Cullercoats cobles were usually built in Hartlepool in County Durham of Larch. They were clinker-built, about thirty feet in length with a beam of about seven feet, the graceful high bows and square rake imported a thoroughbred look. Their equipment consisted of two main masts, accommodating a rig of main lug, jib, and mizzen lug. The square sails were dyed with a brown-red preservative. Cobles were swift sailing and easily manoeuvered. Since their draught was only a few inches, launching and beaching was easy. A crew of four was standard. Most Cullercoats cobles were painted cobalt blue above the water line and white below.

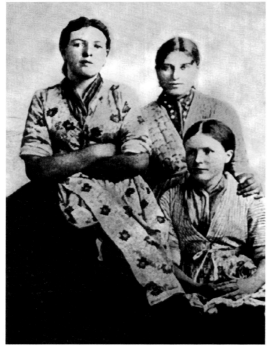

Fig 12. Three Cullercoats Fishergirls - Back left is Sally Sabiston, with Maggie Storey The girl at the front is Rachel Jefferson

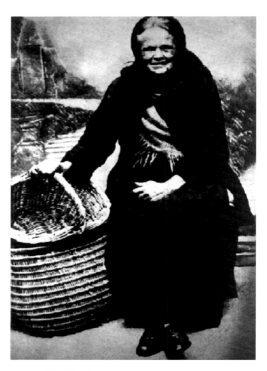

Fig 13. Nanny Lisle

The evening departure of the fishing fleet presented a picturesque sight. The beach would be alive with the bustle of preparation in the carrying of nets and lineswills with their baited lines, and stowing of provisions, the readying of fire pans, and much else. All this would be further enlivened by the fishwives in their traditional garb who assisted with all these activities before launching the cobles and watching them sail off for the fishing grounds. The early morning return, often in the eye of a shimmering sun, signalled a restart of feverish activity in arranging for the disposal of the catch. The fishwives would fill their creels to the brim with fish and start off on foot to sell their catch far and wide. Their bare feet and unstockinged legs–a rare thing in nineteenth-century England–were visible below their highly distinctive traditional costume.

The fishwives toiled ceaselessly. In addition to launching and beaching the cobles, mending nets, baiting lines, sorting the catch, and myriad other duties, they walked for many miles in all conditions of weather with heavy, fish-filled creels slung on their shoulders and baskets on their arms. They began their journeys by climbing the steep slope to the Bank Top and then set out on their journey, hawking their fish to cities, towns, and villages throughout the North East of England. Their traditional cries included this one for herring:

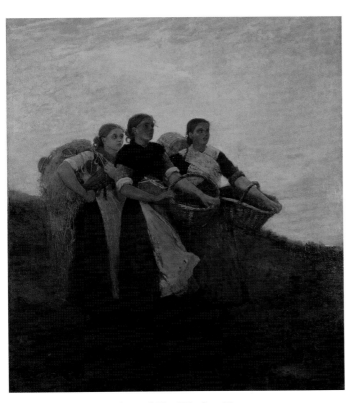

Here's Caller harn

Here's Caller fresh harrin'

Fower a penny Caller harn

Fower a penny, Fower a penny

Fower a penny Caller harrin

Fig 14. "Hark! The Lark" by Winslow Homer
© Milwaukee Art Museum
Layton Art Collection, Wisconsin

Cullercoats fish was bought in quantity by merchants who shipped it by rail to other parts of England, where it was prized for its quality.

Though the fishwives maintained their modest homes and raised children in addition to playing a major role in the fishing industry, their lives were not lived in accordance with any set hours. Their existence was governed by the arrival of the fleet which in turn depended on conditions of weather. Cullercoats folk, men and women alike, were of necessity self-reliant, seasoned toilers.

Early photographs of fisherfolk at their cottage doors, show around the entrances the tools of their calling: lobster pots, creels, line swills, and always a wooden barrel. The barrel contained layers of the once-plentiful herring, alternating with layers of coarse rock salt. The herrings were "laid" about the end of September, at the time of the glut. It was an essential task in any household, as herring provided basic sustenance from mid-winter to the following March. As one Cullercoats native expressed it, "one day we have herrins and spuds, and the next day we change it to spuds and herrins."

The hours spent by fishwives hawking their wares was scarcely exceeded by those spent baiting lines. For Cullercoats fishermen, mussels were the essential bait for line fishing.

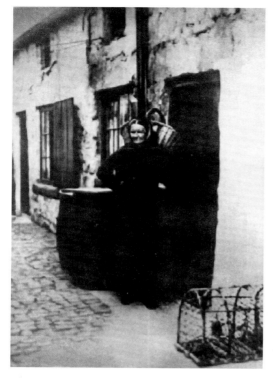 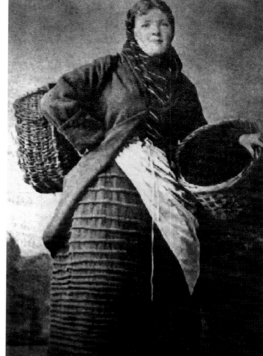

Fig 15. Betty Scott outside her home *Fig 16.* Belle Jefferson

They obtained them from the Tees Bay mud flats where the mussels thrived in clusters under wooden piles and were easily detached. The fishermen would load their cobles to the gunnels (gunwales) with mussels, then turn north and home to Cullercoats where their wives would bait the hooks. This task had the highest claim on the women's time since without baited lines, no fishing was possible, and without fishing there was no income to pay for the household expenses.

Each heavy-duty fishing line was 600 yards in length. At three foot intervals along the line were trammel stubs, each with a No. 19 Haddock Hook. The task of baiting 600 hooks on each of eight 600 yard lines would be a daunting chore for most people, yet the fisherfolk did it routinely. As the hooks were baited, the lines were carefully laid, hook first in the mouth of the wicker line swill, and also arranged so that the line would run free at the fishing ground. Thus a crew of four fishermen, each with two fully baited line swills, would set out 4800 baited hooks. They did this from September to January, catching haddock, codling, and other types of fish. The fishwives then got relief from baiting from February to August when the men fished with nets for salmon. The women's home task then became the intensive one of net mending. The men also routinely set out pots for lobster.

In time, the sailing coble became outmoded. The development of the steam-engined trawler in 1877 at the neighbouring port of North Shields signalled the beginning of the decline.[1] Though Homer saw the famous Cullercoats fishing fleet in its prime, within a few years of his visit the cobles and the fishwives had begun to disappear. The old character of the once-bustling community survived to some extent into the early decades of the twentieth century, but not significantly thereafter. Today only a few fisherman's cottages remain. Three full time coble fishermen still work out of Cullercoats, but all of the fishwife activities have long since disappeared. Still, Cullercoats remains fixed in history as a village whose very life depended on fish.

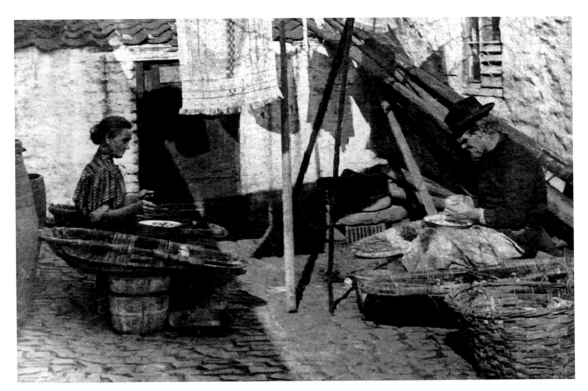

Fig 17. "Hallelujah" Jack Brunton and his wife baiting lines

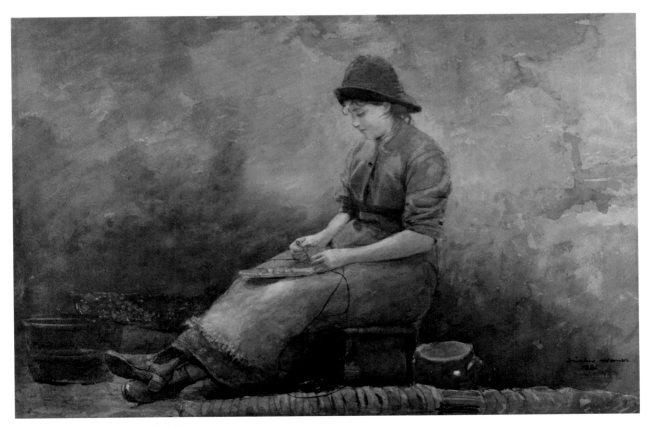

Fig 18. "A Fishergirl Sewing" by Winslow Homer
(The fishergirl is actually baiting lines)
©*Yale University Art Gallery. Bequest of Christian A. Zabriskie*

9

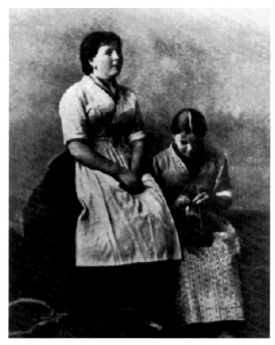

Fig 19. Belle Jefferson and her younger sister Rachel

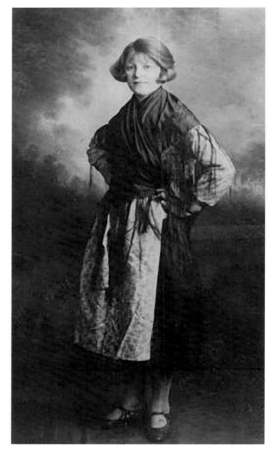

Fig 20. Elizabeth Brunton

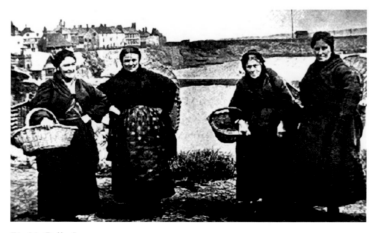

Fig 21. Belle Storey,
Barbara Storey,
Mrs. Ferguson,
and Maggie Storey

ARTISTIC CULLERCOATS

When Winslow Homer arrived in Cullercoats in the spring of 1881, he found not only one of England's most famous fishing enterprises but also a small and flourishing artistic community. For some years the rugged coastal scenery and the individuality of the fisherfolk had attracted artists from all over Britain. Some of the villagers were employed from time to time as models, not only in their usual roles with their characteristic local costumes, but occasionally also as figures for academic studies. Joe Robinson, a fisherman of impressive appearance on account of his size and wavy brown beard, had modeled as the ancient Greek poet, Homer, for the local artist Henry Hetherington Emmerson. When Robinson later met the newly arrived, beardless American artist Winslow Homer, he asked:

"Do they caall ye Homer?"

"I guess that is my name," came the response.

"A'ave sat for ye," said Robinson.

"I don't understand you, what do you mean?" enquired Homer.

"Wey! aad Emmerson had me half-nyeked sitting for Homer, an 'aa'm tell'd that yor him!"[2]

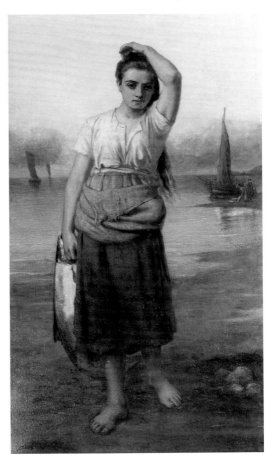

Though the early 1880's saw the peak of artistic activity in Cullercoats, the village had become a centre for painters much earlier in the nineteenth century. The three leading Tyneside artists, working in Newcastle upon Tyne during the first half of the century, were Thomas Miles Richardson, Henry Perlee Parker, and John Wilson Carmichael. Richardson seems to have been the first to discover and treat the picturesque qualities of this village perched above a crescent beach. The village he knew consisted of about ninety buildings housing a population of less than five hundred. Carmichael painted many coastal scenes at and near Cullercoats, including a series of panels for the Duke of Devonshire at Chatsworth House. Parker made his reputation from genre and anecdotal subjects. Some villagers modeled for his scenes of smugglers at work. These three artists encouraged others to work in the village. John Henry Mole painted there before moving to London in 1847.

Artistic interest in Cullercoats waned at mid-century until Henry Hetherington Emmerson settled there in the 1860's. Emmerson, a native of Chester-le-Street, County Durham, had been trained at the Government School of Art in Newcastle upon Tyne by William Bell Scott, and had then resided in Paris and London. He became a devoted follower of John Ruskin and on his advice

Fig 22. "A Cullercoats Fishergirl"
by H. H. Emmerson
Collection Unknown

returned to the countryside for inspiration. He settled first in Ebchester and then Tosson near Rothbury, where he was close to his principle patron, Lord Armstrong. Emmerson bought a house in Cullercoats in the 1860's, but did not settle there completely until 1888. As founder-president of the Bewick Club in Newcastle upon Tyne, which was the meeting place for most North East artists, he served as a father figure in the art world of the region up to his death in 1895. He painted scenes from history, legend, and poetry as well as many genre subjects. Emmerson was also an illustrator, and together with J.G. Sowerby, produced children's books similar to those of Kate Greenaway.

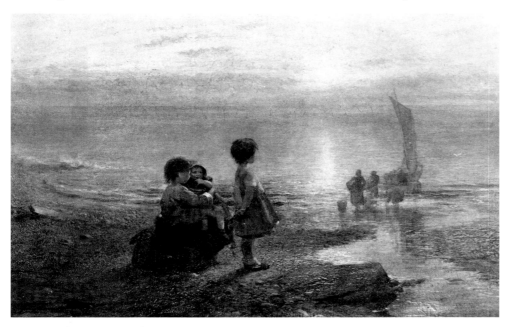

Fig 23. "Early Morning on the Coast"
by Henry Hetherington Emmerson
© *Laing Art Gallery, Newcastle upon Tyne, England*
(Tyne & Wear Museums)

The brothers Stephen and George Washington Brownlow opened a studio in Cullercoats, and one of the most famous locally born artists, Charles Napier Hemy, stayed with them on the only occasion that he painted the coast near Cullercoats. His success as an artist kept him in London and Falmouth. His brother, Bernard Benedict Hemy, was also a regular visitor to Cullercoats.

By the 1870's, the reputation of Cullercoats as a picturesque locale had become nationally known. A group of artists well known in their time came to visit Alexander Stevenson, at one time chairman of the local newspaper, the *Shields Gazette*, who lived at the Old House in Tynemouth. These artists were J.D. Watson, his brother T.J. Watson, William

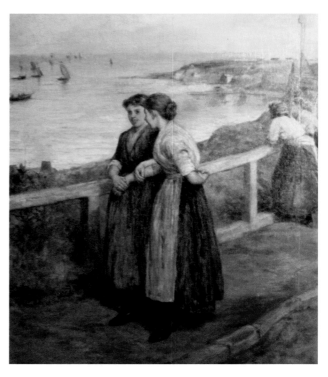

Fig 24. "Fishergirls on the Bank Top"
by Robert Jobling
Private Collection

12

Quiller Orchardson, and A.H. Marsh. All were friends of Birket Foster who had probably also praised the area and encouraged them to visit. Orchardson spent four or five months in Cullercoats painting *Toilers of the Sea*, which was shown at the Royal Academy in 1870. J.D. Watson painted the fisherfolk and became a popular figure in the village. When Joe Robinson, his favourite model, lost his coble in a storm, Watson bought him a new one. Robinson named it the J.D.W. after his benefactor. Arthur Marsh was so impressed by Cullercoats that he settled there. Frank Holl painted in Cullercoats in 1870 to satisfy a commission from Queen Victoria who had seen earlier work of his at the Royal Academy. The resulting painting, *No Tidings from the Sea*, depicted four sad figures in a cottage interior.

Among the artists of Homer's generation, and younger, was Robert Jobling, a native of St. Lawrence in Newcastle upon Tyne who resided at Cullercoats. His paintings of the village and its people won him national acclaim. Of all the artists who painted there, he seemed to capture best the spirit of the place and the people. His second wife, Isabella Thompson, was also an artist of notable achievement. John Falconar Slater, a painter of quite a different style, was a self-taught artist best known for his marine subjects.[3]

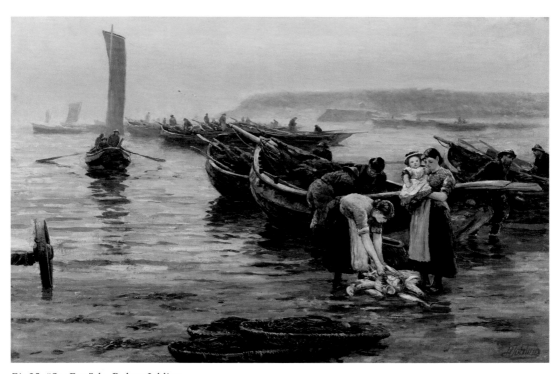

Fig 25. "Sea Fret" by Robert Jobling
© *Laing Art Gallery, Newcastle upon Tyne, England*
(Tyne & Wear Museums)

The village was prized for its picturesqueness not only by artists, but also by tourists. The nearby town of Tynemouth had a large population of summer visitors, as did several coastal villages to the north. In the years surrounding Homer's visit, pictorial magazines included illustrations of the village, emphasizing the distinctive costumes of the fishwives and the picturesque qualities of the rock-enclosed bay, its beach at the right hours crowded with cobles and alive with fishermen and fishwives. Tourists watched this activity with fascination from the roadway above. It was a colourful and appealing subject for the artists; most of those I have mentioned were drawn to it, as were others, but none of these English artists were so deeply affected by the fisherfolk and their way of life as was the American, Winslow Homer.

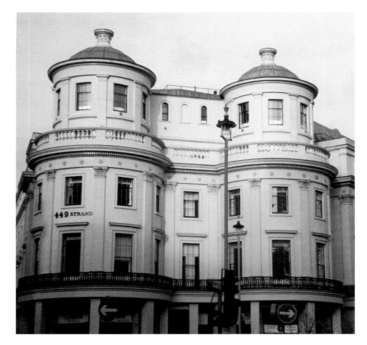

Fig 26. 449 The Strand today

Fig 27. 449 The Strand today,
flanked by the church of
St. Martins in the Field
and the National Gallery

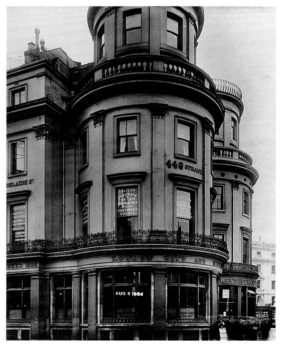

Fig 28. 449 The Strand in 1904
Westminster City Libraries

Homer exhibited with some of them at least once. In the autumn 1881 exhibition of the Newcastle upon Tyne Arts Association which ran from 26 August to 29 October, Homer exhibited one work. It was a watercolour, item No. 33, entitled simply *Cullercoats*. (It is probable that this is the work now known as *Fishergirls on the Beach, Cullercoats, E90*.) Homer priced it at forty pounds. Other artists who exhibited included not only Jobling, Emmerson, Charlton, and J.D. Watson, but also such internationally known artists as James Tissot, Erskine Nicol, and Leon Shermitte. The exhibition was of more than local significance. Newspaper reviews of the exhibition, which was held in the Assembly Rooms in Westgate Road, Newcastle upon Tyne, indicate that space was only available for about half the paintings that were submitted, which may explain why Homer was represented by only one work.

The review in the Newcastle Courant mentions Homer's work, although attributing it to Winslow Heron! It states, "Winslow Heron, an American artist residing, we believe, at present in Cullercoats, contributes a charming sketch, containing a couple of wonderfully drawn figures."[4]

Another review of Homer's entry, in the Tyneside Daily Echo, mentions a sketch of "Two Cullercoats Fisher Girls" by W. Homer, an American artist who is evidently influenced by Jules Breton. There is an attempt to catch the noble forms and attitudes so frequently to be found in the toilers of the earth and sea, who are unfettered by modern unconventionalities of costume. The aim is an admirable one, for on our English coasts and fields are to be found types of simple and noble beauty equal to those which inspired the old Greek masters, when they gave to the world treasures of hewn marble that stand out clear and unrivalled in all the succeeding years."[5]

When submitting his painting for the 1881 exhibition of the Newcastle upon Tyne Arts Association, Homer gave his address as Cullercoats and 449, The Strand, London. 449 The Strand, which formed part of the West Strand Improvements of 1830-32 planned by the renowned architect, John Nash, had among its occupants in 1881 the American Exchange in Europe Ltd., with Henry F. Gillig as manager. This was the shipping agent that Homer used to send his paintings to his dealer in New York, J. Eastman Chase.

Fig 29. The Old Assembly Rooms 1965
Newcastle upon Tyne City Libraries & Arts

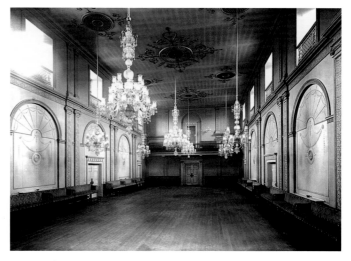

Fig 30. The Interior of The Old Assembly Rooms 1933
Newcastle upon Tyne City Libraries & Arts

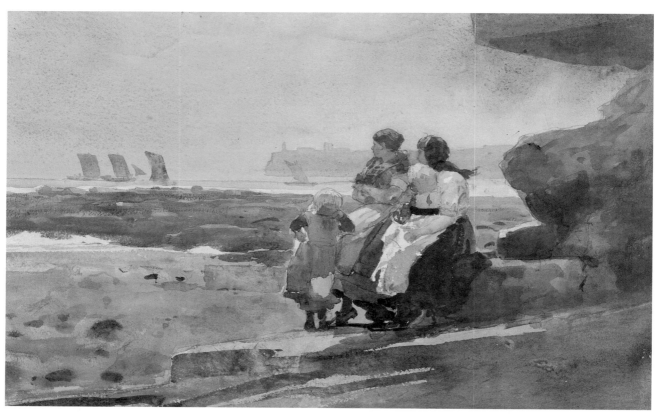

Fig 31. "Under the Cliff, Cullercoats" by Winslow Homer
© *Addison Gallery of American Art*
Phillips Academy, Andover, Massachusetts

Homer had sailed from New York on Wednesday 16 March 1881, leaving from pier No. 40 aboard the *S.S. Parthia* at 5.30 a.m.[6] The ship was of the Cunard Line. It weighed 3,167 tons and had been built by Denny of Dumbarton and launched on 10 September 1870. The ship sailed under the command of a Captain McKay. The *Parthia* arrived in Liverpool on Monday 28 March. Homer went first to London, making arrangements with his shipping agent, and perhaps visiting the British Museum, the National Gallery, and other places of interest. He may also have attended the opera, of which he was fond. After a short stay in London, during which he painted a watercolour of the Houses of Parliament, he travelled north to the East Coast town of Scarborough, in North Yorkshire, staying at the Castle Hotel for a few days before continuing his journey to Cullercoats as planned. He had wanted to see the town from which Scarborough, Maine had taken its name, (of which Prout's Neck is part), and took the opportunity to do so whilst journeying north to Cullercoats.

He travelled by train to Scarborough, and then on to Newcastle upon Tyne. Arriving in this bustling city, he then took a horse drawn cab to Cullercoats, ten miles eastward. A railway link to Cullercoats did not open until a year later, in the spring of 1882.

Homer probably went straight to the Huddleston Arms Hotel (now the Bay Hotel), since it was the only suitable accommodation for visitors in the village. He was given a room on the first floor above ground level at the front of the hotel, a room which offered superb views across the bay with the ruins of Tynemouth Priory and Castle clearly visible on the rocky prominence of Pen Bal Crag some two miles southward along the coast.

Homer's reasons for coming to Cullercoats have long been the subject of much speculation. He may have known of its popularity among English artists and he may have seen illustrations of the picturesque village and distinctive fisherfolk in popular illustrated magazines. The American artist, Edwin Austin Abbey, a longtime acquaintance of Homer and who had resided in England since 1878, may have told him about the place. So also may have the painter M.F.H. De Haas, Homer's former neighbour in the Studio Building in New York, who settled in England. John George Brown, who had spent his boyhood in Newcastle upon Tyne, but who had lived and painted in America since 1856, may have extolled the assets of the village for artists. Homer knew all of these artists and others with English connections as well. But there is no reason to suppose that any comments of theirs necessarily played a critical part in his decision to journey to the village.

Fig. 32. Advertisement for the Huddleston Arms Hotel.
From Ward's Street Directory 1881-82

It is entirely possible that art had little to do with the choice of locale. The salubriousness of the Cullercoats climate among those who believed in the efficacy of bracing weather may have been a factor. The daughter of Maggie Storey, Homer's favourite Cullercoats model, told me that her mother believed that Homer came to Cullercoats for reasons of health. She also believed that he intended to stay for only two months, but was so taken with the village and its people, that he stayed for a year and a half. A rumour that Homer went to England because he had found himself drinking too much in New York, probably has no basis in fact. It would not in any case explain why he went to Cullercoats rather than to some other place. His choice of the village may have come from advice given to him by a couple who had emigrated from Northumberland to America and whom Homer knew in Gloucester, Massachusetts, in the summer of 1880. But though tradition exists that this couple praised Cullercoats as a picturesque place, no documentation exists to support it or the notion that Homer was following the advice of anyone in America.

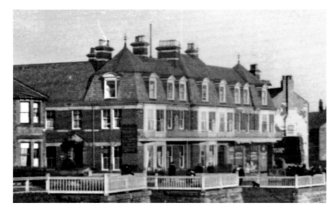

Fig 33. The Huddleston Hotel in the early 1900's

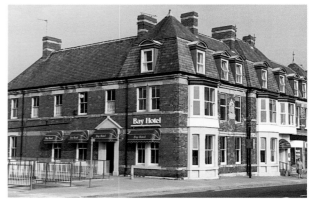

Fig 34. The Huddleston Hotel (now the Bay Hotel), today

Robert Demarest believes that Homer's love of fishing and his regard for the accomplished wood engraver Thomas Bewick (1753-1828), who was born a few miles from Tynemouth, influenced his decision to visit the area.[7] Bewick spent many hours fishing the river Tyne, and produced illustrations depicting the more amusing aspects of the sport.

Following the Winslow Homer Centenary Exhibition in the Bay Hotel in 1981, evidence has come to light, in a memoir by Alan Adamson, to suggest that a man whom Homer met while crossing the Atlantic on the *Parthia* may have directed him to Cullercoats. Adamson, who knew Homer in Cullercoats, recalled a few years after Homer's death that one of Homer's fellow passengers on the *Parthia*, "told him to go to the village... where he would find the subjects for his brush that he was seeking."

The *Parthia* had twelve first class passengers on board: W. Carmichael, G. Clayton, William Court, J.L. Gibbon, Winslow Homer, C.B. Macdonald, James Shaw, A.H. Silverthorne, Edward Taylor, L.A. Tulley, William Wilson, and a Miss Womack.[8]

The first name on the passenger list, that of W. Carmichael, is one to conjure with. Could this have been a relative of the well-known marine, landscape and figure painter, John Wilson Carmichael? J.W. Carmichael had been born in Newcastle upon Tyne in 1799, set up his first studio there in the 1820's, and painted there for twenty-odd years, frequently undertaking subjects in Tynemouth and Cullercoats. He later moved to London and subsequently relocated in Scarborough in North Yorkshire where he died in 1868. His two sons pre-deceased him. The W. Carmichael who crossed the Atlantic with Homer on

board the *Parthia*, left the ship at Queenstown in Southern Ireland, and this fact perhaps diminishes the likelihood that he was a relative of Carmichael the painter and might have sung the praises of one of his kinsman's favourite villages.

A more likely candidate for the role of a shipboard companion who recommended Cullercoats to Homer was James Shaw. A James Shaw was at that time landlord of one of the four public houses in the village. The 1881-82 edition of Ward's Street Directory lists Shaw's address as being the Queen's Head Public House in Front Street, Cullercoats. The Queen's Head, which was built in 1813, still stands in Cullercoats, and is the only remaining licensed pub in the village. Shaw had relatives in the United States and also in London and other parts of England. It is known that he visited his relations in the United States on at least one occasion, and it is possible that he was there in early 1881, returning home on the *Parthia* where he met Homer and told him of Cullercoats and its attraction to artists. It is intriguing that the 1881 census taken on 11 April that year, does not list Shaw as being resident at the Queen's Head, or indeed anywhere else in the village on that date. This fact suggests that he was away from home; so perhaps he had been in the United States and, after arriving in Liverpool on 28 March, took the opportunity to visit other relatives or attend to some business, returning to Cullercoats sometime after 11 April.

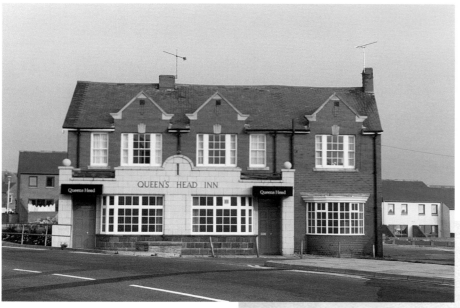

Fig 35. The Queens Head Inn today

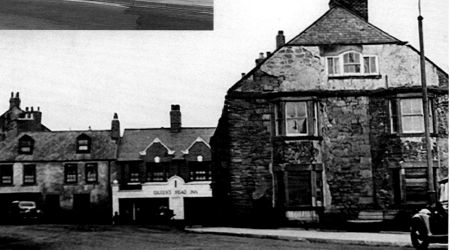

Fig 36. The Queens Head Inn in the 1930's
North Shields Central Library

Fig 37. No.12 Bank Top

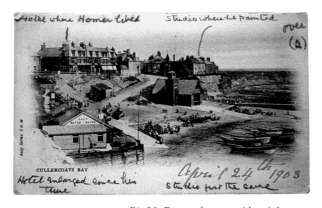

Fig 38. Postcard sent to Alan Adamson by his sister Fanny Carr. The annotations are in Adamson's hand

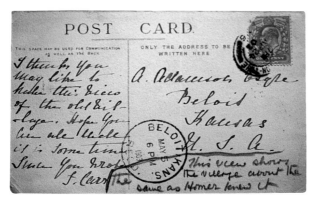

Fig 39. Reverse of Post Card

At any rate, it is very probable that James Shaw, the landlord of the Queens Head in Cullercoats, was indeed the shipboard companion on the *Parthia*, who, according to Alan Adamson, told Homer of the attractions of the village, and gave him directions to get there.

After arriving in Liverpool, Homer went first to London, where he spent at least enough time to paint his watercolour view of the Houses of Parliament, and to make arrangements with a shipping company to transport his paintings to J. Eastman Chase. He then travelled to Cullercoats, via Scarborough, arriving sometime after 11 April (he does not appear in the 1881 census of Cullercoats taken on that date.)

In Cullercoats he first lodged in the Huddleston Arms Hotel (now the Bay Hotel), and looked around for suitable premises for a studio and subsequently for a house to rent that would provide him with some privacy. William Weaver Tomlinson, writing in 1893, said, "Winslow Homer, while at Cullercoats, used as a studio a room in the house occupied by Miss Carrick (12 Bank Top), the daughter of Thomas Carrick, who for his skill as a miniature painter and his invention of painting his portraits on marble instead of ivory, gained a considerable reputation during the earlier part of the Victorian era." [9] Miss Carrick is not listed in the local directory as residing at this address until 1886. In 1883 she is listed as being at 18 John Street, Cullercoats, the address also of H.H. Emmerson. The 1881 census does not list 12 Bank Top or its occupants, presumably because it was unoccupied at the time.

Alan Adamson, who knew Homer well, indicated on a postcard postmarked 24 April 1903, that the studio was at 12 Bank Top. One further bit of evidence is a story traditionally told about Robert Jobling's painting of 1885 titled, *The Day is Done and Darkness Falls from the Wings of Night.* In this painting, which depicts the Cullercoats Watch House, the houses along the Bank Top are shown in the background with a light shining from the window of No. 12. It has been suggested that Jobling singled out this window as a mark of respect for Winslow Homer.

Fig 40. "The Day is Done and Darkness Falls from the Wings of Night" by Robert Jobling © *Laing Art Gallery, Newcastle upon Tyne, England (Tyne & Wear Museums)*

While it seems quite clear that Homer had his studio at 12 Bank Top, at least for most of his stay in Cullercoats, the evidence concerning his residence is quite mixed. Homer's first biographer, William Howe Downes, writing in 1911, probably from information supplied to him by Homer's brother Charles, said that, "In a suburb called Cullercoats, he was fortunate enough to find a dwelling which just suited him, a little house surrounded by a high wall with one gate, to which he had the key, so that he was safe from intrusion."[10]

John Boon, a local historian and resident of Tynemouth, who spent many years researching various aspects of Homer's visit to Cullercoats, began with this reference. He visited Cud Simpson, a sturdy son of senior years and true native of Cullercoats whose family roots in the village date back through centuries. Simpson then lived in his ancestral home, Dove Cottage. They discussed Downes' description of Homer's residence and Simpson recollected a dwelling which corresponded to it. This building, dating from the eighteenth century, was one of two cottages accessed by a gate from Front Street. An examination of Ordnance Survey maps was undertaken to identify other possibilities, but none were found. Discussions with other of the villages older residents identified no other cottages with a high wall and lockable gate. It seems likely then that Homer lived in one of the two cottages on the west side of Front Street, north of the Newcastle Arms Public House, and behind the Stone House. When Boon visited this site in 1976, a major housing development was about to commence there. The cottages were no longer standing, as they and Stone House had been destroyed during an Air Raid in 1941, but sections of the north and west perimeter walls of the cottage gardens still stood, along with a well from where the cottage occupants drew their water. I reviewed the evidence of the site with John Boon and Cud Simpson in 1980, and concluded that they were correct in their identification of the site of Homer's residence: either 43 or 44 Front Street. The cottages were owned by a Mrs Elliott who lived in one and rented the other, probably no. 44, to Homer.

Fig 41. The High Wall surrounding Homer's Cottage

Fig 42. The well used by the cottage occupants. Photographed by John Boon in 1976

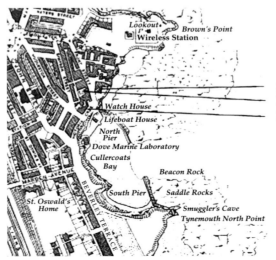

Homer's Studio
Homer's Cottage
Huddleston Hotel

Fig 43. Map showing location of Homer's residences in Cullercoats

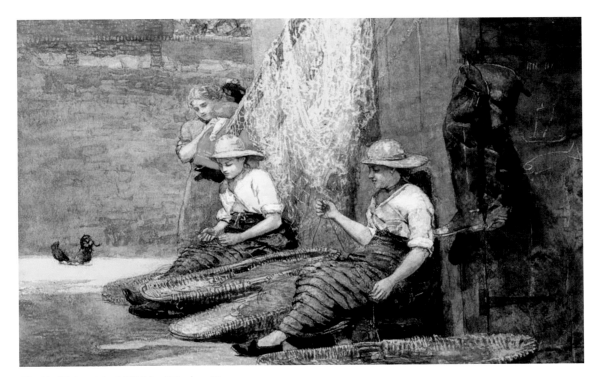

Fig 44. "Fishergirls, 1881" by Winslow Homer
Private Collection
The Fishergirls are at the side of Homer's cottage.
The High Wall can be seen in the background

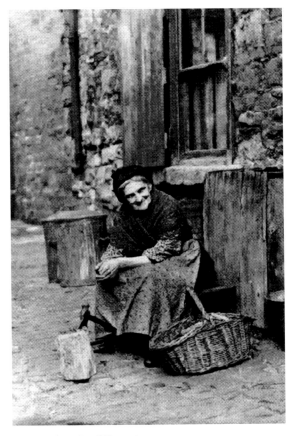

Fig 45. Taken outside the front of Homer's
Cottage on Carnival Day in 1927. The girl
at the back right hand side is Mary Robson,
who has confirmed the location

Fig 46. The side of Homer's
cottage pre-1900

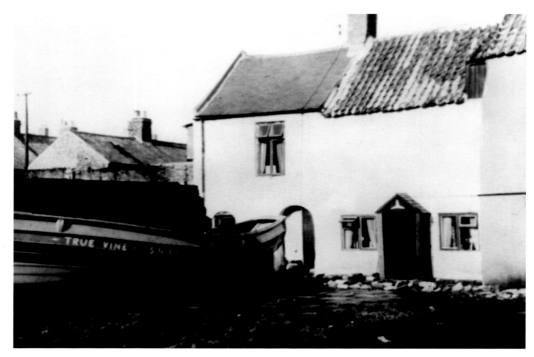

Fig 47. 43 and 44 Front Street,
Cullercoats

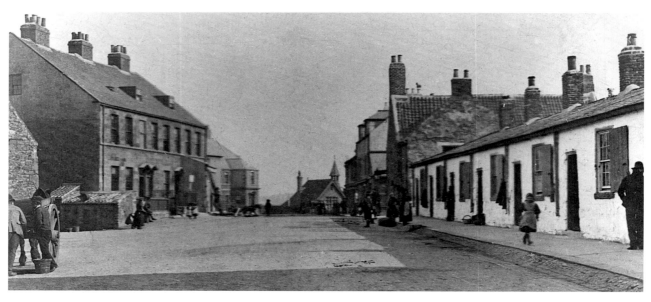

Fig 48. Front Street,
Cullercoats, 1893

With the more recent discovery of Alan Adamson's manuscript and his notes on the postcard of 1903, quite a different residence is specified. Adamson states that his friend Homer lived in the Huddleston Arms Hotel. Unfortunately, the records of the hotel go back only as far as 1911, when the building gained new owners and was re-christened the Bay Hotel. Adamson's daughter Constance recalled that her father mentioned that Homer's room at the hotel was No. 17 on the first floor, and that it had a splendid view over Cullercoats Bay.

Room 17 is presently on the second floor of the hotel and does not have a view over the bay. The hotel was enlarged in the 1890's and it is therefore probable that the rooms were re-numbered at that time. The small resident's lounge on the first floor offers a magnificent view of Cullercoats Bay from it's bay window, and may well have been the bedroom occupied by Homer when he first arrived in the village. The view is that which Homer painted in his *Perils of the Sea*.

Fig 49. Ralph Brunton

Adamson made no mention of a cottage surrounded by a high wall, but perhaps Homer moved there after Adamson left for America in April 1882.

Maggie Storey's daughter, May Thorrington, remembers her mother telling her that Homer lived in Beverley Terrace. Beverley Terrace is a continuation of Front Street, on which the Huddleston Arms Hotel was located, and it is possible that the two street names were confused. There was, however a guest house (the only one in the village) at No. 16 Beverley Terrace, owned and operated by Dorothy Green and her sister Ann Hansell. Perhaps Homer lived in three different places during his eighteen months in Cullercoats.

Homer obviously appreciated the hospitality afforded to him during his stay at the Huddleston Arms Hotel, for he presented his watercolour *Daydreaming*, painted in 1880, to Mrs William Chapman, wife of the owner of the hotel.[11]

Homer's persistent desire for solitude had begun to manifest itself long before his visit to England. The American writer Henry James said of him, as early as 1875, "Of Winslow Homer's movements in summertime no person, however intimate is ever supposed to have the secret." Much later in his life his future biographer, William Howe Downes, art critic of the Boston Transcript, asked if he might write a biography. Winslow replied, "I think that it would probably kill me to have such a thing appear and as the most interesting part of my life is of no concern to the public, I must decline to give you any particulars."[12] There has never been any suggestion that Homer was furtive, or that he had anything to hide; to the contrary, he was a transparently honest, highly proper Victorian gentleman. He was reserved, a man of few words, disinclined to discuss his work, and impatient with those who misunderstood it. He was a self sufficient, resourceful man with an aversion to personal publicity.

In Cullercoats, he sought the company of homely folk of walnut grain who had had no opportunity for a formal education. To these hard working folk he extended genuine kindness. Although he held himself somewhat aloof from other artists during his stay in the village, he was not unsociable with the townsfolk. One of the mobile tradesmen who called on Homer with provisions often prolonged his visit to chat, smoke, and then give his opinion of the artist's latest picture. Although he was not very communicative with fellow established artists, he encouraged Thomas Eyre Macklin, then eighteen, who later enjoyed a successful career as a portrait painter. At the time of Homer's visit, Macklin painted a number of attractive pictures of the Cullercoats women and children.

Homer did form a few friendships. One was with a Cullercoats fisherman, Ralph Brunton. Ralph, his wife Mary and their children Ralph, George and John, lived with Ralph's parents Ralph and Ann Brunton at the family home at No. 4 The Square. Ralph was 34 years old when he met Homer in 1881. Before returning to America the following year, Homer presented Ralph with three small drawings. Ralph subsequently moved his family to nearby North Shields taking with him the three drawings securely flat inside the leaves of the family bible. After Homer's death in 1910, an American art dealer visited Cullercoats in search of any paintings that might still be there and learned of Ralph Brunton's drawings. The dealer located him in North Shields, talked with him about his friendship with Homer, and asked to see the drawings. Ralph asked his married daughter to get them. "Do you mean those three paintings we've kept in the family bible these many years?" she asked. "Certainly." "Why it's only a few weeks ago since I gave them to the children to look at and they completely destroyed them."[13] While the fate of these works is clear, what remains unknown is how many, if any, other drawings and watercolours Homer may have presented to villagers.

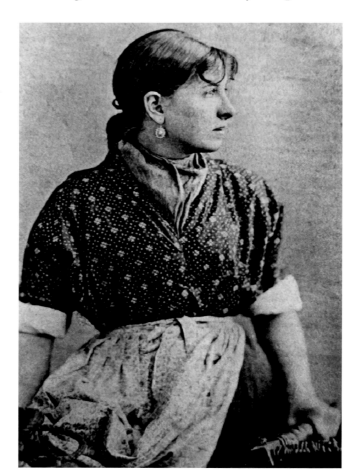

Fig 50. Maggie Storey aged 18

While in Cullercoats, Homer's favourite model was Maggie Storey (Maggie Jefferson when Homer knew her before her marriage to Robert Storey). Maggie was thought to have been 15 or 16 years old when Homer, then aged 45, first arrived in Cullercoats as she gave her age as 89 when interviewed by Kay Jenner in 1956.[14] However, recent research by Ron Wright for his book on Cullercoats and its fisherfolk, suggests that Maggie was much younger when Homer arrived in 1881. Wright reviewed the 1881 census and has concluded that Maggie was the daughter of James and Isabella Jefferson who resided at 45 Front Street, adjacent to the cottage that Homer rented. Maggie is recorded as being 12 years old when the census was taken on 11th April 1881.[15]

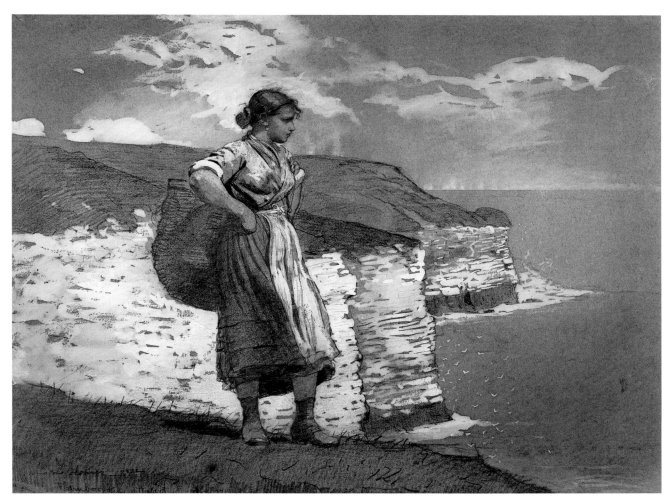

Fig 51. "Flamborough Head"
by Winslow Homer
The model is Maggie Storey
© *Art Institute of Chicago*
Chicago, Illinois

She appears in many of his works and he seems to have formed as close a relationship with her as he did with anyone in Cullercoats. From all evidence, it was a genuinely affectionate relationship and a thoroughly proper one as well, for no hint of scandal linking these two has ever been part of local lore. He was often seen painting her on "The Green", the area behind Beverley Terrace where Cullercoats School now stands, though he also painted her in his studio. He paid her one shilling per day to pose for him. May Thorrington, one of Maggie's seventeen children, recalls that her mother told her that Homer asked her to return to America with him, but she declined the invitation.

In 1956, Maggie remembered that Homer had taken many photographs of her in 1881 and 1882 and that he had presented her with an album of them. The album had apparently been mislaid before 1956. None of Maggie's surviving children or grandchildren that I have spoken to have knowledge of its whereabouts. But though the album of Homer's photographs of Maggie is lost, the type of camera with which he probably took them is known. While in England he purchased a camera manufactured by Marion & Company of London. It used $1\frac{1}{4}$ inch square photographic plates. One of Maggie's granddaughters, whom I visited in 1982, recalled two photographs of Maggie that might possibly have come from the album. They were given to Maggie by Homer, she says, and once adorned her mantelpiece, but her mother (Maggie's daughter), had disliked the photographs and thrown them away a few years earlier.

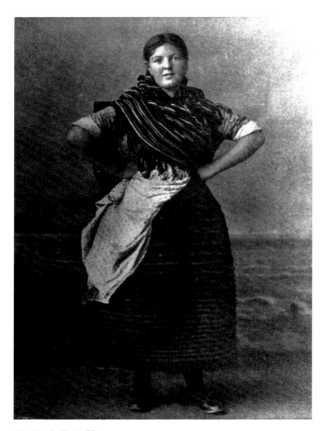

Fig 52. Belle Jefferson

Fig 53. Belle Jefferson
and her sister Rachel

A photograph of a Cullercoats coble measuring $2\,{}^{3}/_{16}$ x $4\,{}^{3}/_{16}$ inches was discovered inside the endpapers of one of Homer's books: M.E. Chevreul's *Laws of the Contrast of Colour.* The book is now among the collection of volumes from Homer's personal library in the Strong Museum, Rochester, New York. The photograph shows a Cullercoats coble in silhouette with a fisherman hoisting the sail up the boat's mast. An inscription in Homer's hand below the photograph reads, "September 1882 Cullercoats Newcastle on Tyne."[16]

Homer and photography is a subject that has been given close attention only in very recent years and our knowledge of the subject is still quite limited. But it seems possible that Homer used the medium of photography in Cullercoats to a greater extent than he ever had before. Indeed, it may have been his first serious, extended use of the media, though we really know very little of his practice beyond the lost album and the single view of a coble. The atmospheric conditions of the village would have precluded Homer's models from undertaking lengthy sessions in the open air on most days. More likely, he would sketch his models on these occasions, then photograph them, using both drawings and photographs to compose, refine, and finish his paintings in the relative peace and calm of his Bank Top studio.[17]

Along with the photographs, he probably also used the small wooden mannequins dressed in the style of local fishwives that he obtained while in England and that are preserved in the Homer Collection at Bowdoin College. Like other figure painters of the era, he used mannequins to study the play of light on a costumed form. He could have purchased his mannequins at Poletti's Bazaar on Front Street in Tynemouth, which shop stocked them for artists. One mannequin in Homer's studio at the time of his death was still dressed in the typical garb of the Cullercoats fishwife. It is reminiscent of the figures depicted in his painting, *Hark! The Lark.*

Another of Homer's models in Cullercoats was Belle Jefferson. Maggie and Belle were good friends but not related. Belle appears in a number of Homer's paintings alongside Maggie.

While in Cullercoats, Homer also became interested in Grandfather clocks and purchased several. Writing in 1939, George Horton recalled that, "The Cullercoats folks liked Homer being with them, for he was lavish with his money. He more than doubled the earnings of those who sat for him as models and he also had a craze for clocks… he must have bought almost a dozen grandfather clocks at the regular figure of ten pounds a piece, no matter how poor the clock might be; then he had cases made for each of them, which meant more money."[18] As to what became of them, no one knows. It seems certain that he did not take them back to America with him. Perhaps he sold them or gave them away to the Cullercoats folk. Kay Jenner mentioned that he had two of them securely packed for shipment to America.[19]

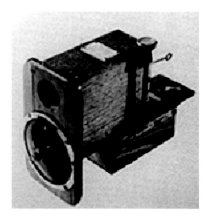

Fig 54. Homer's Camera
© *Worcester Art Museum*

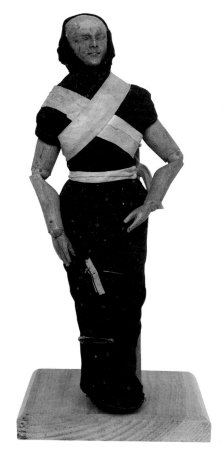

Fig 56. One of the mannequins found in Homer's studio
© *Bowdoin College Museum of Art, Brunswick, Maine*

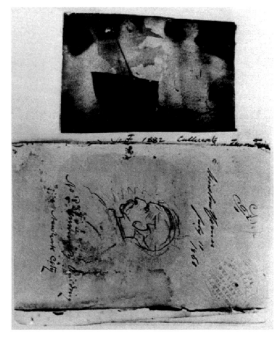

Fig 55. The Cullercoats Coble photograph
© *The Strong Museum, Rochester, New York*

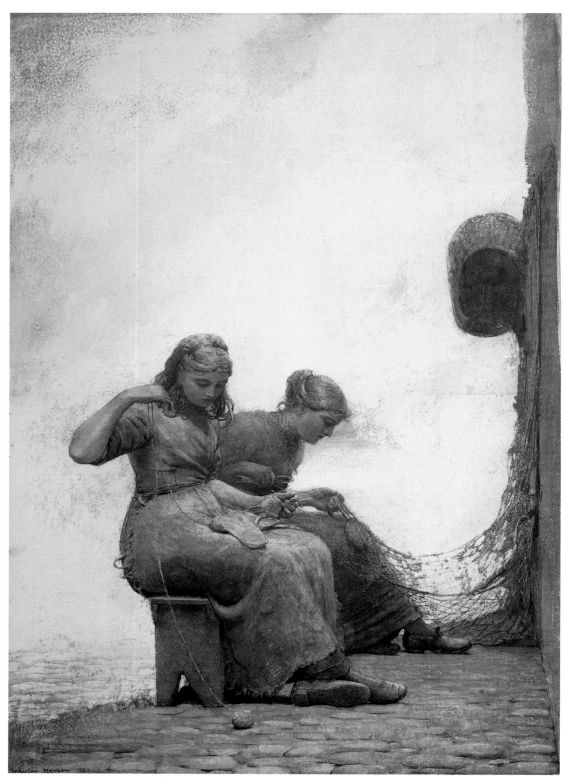

Fig 57. "Mending the Nets"
(or "Far From Billingsgate")
by Winslow Homer
© *National Gallery of Art*
Washington, D.C.

Fig 58. Garden House *Fig 59.* Entrance to Garden House

HOMER'S FRIENDSHIP WITH ALAN ADAMSON

Among Winslow Homer's acquaintances in Cullercoats were members of the Adamson family who resided at Garden House, a large residence in the Village. William Adamson was a solicitor born in Newcastle in 1818. He had been a major in the Militia and compiled and edited *Notices of the Services of the 27th Northumberland Light Infantry Militia.* He was appointed senior captain and honorary major in 1877. He lived at Garden House with his wife Hannah and their children Constance, Bryan, Alan and Elonor. William Adamson was an amateur architectural and coastal painter in watercolour.

William Adamson's son Alan befriended Homer. Alan Blythsman Adamson had been born in Cullercoats in 1861 and trained as a mechanical engineer at Lord Armstrong's factory in Scotswood, Newcastle upon Tyne. He had tired of his trade at about the time Homer came to the village, and was temporarily a gentleman of leisure. Coming from a well-to-do middle class family, he had affinities of class with Homer, and knowing the villagers well, he arranged for some of the younger fisherlasses to pose for the artist. As Alan was then looking for new opportunities, the arrival of someone with American connections seems to have opened new possibilities. With Homer's encouragement, he travelled to the United States in the Spring of 1882 to seek his fortune. Homer furnished him with a letter of introduction.

After a brief stay in New England, Alan Adamson settled in Kansas and became a successful farmer. Although he had apparently intended to return to England, he met the girl who was to become his wife, gave up farming, and purchased a newspaper, the *Beloit Daily Call*, of which he became editor and publisher for the rest of his working days. The newspaper, which flourished under Adamson, had as its slogan "The Beloit Daily Call, tells it all." In 1922, Adamson wrote his recollections of Homer's visit to Cullercoats. He may have intended to edit and publish them, but he never did. The manuscript is published here. It is presented in its entirety, with only minor changes in capitalisation and punctuation.

Cullercoats
Newcastle – on Tyne
England
April 22nd 1882

Mr. A. Warren Kelsey,

Dear Sir :

This will introduce to
you ~~my~~ my friend.,
Mr. A. Adamson.

He visits America for
the purpose of farming.

Consider any favor
done for Mr Adamson
as done for me.

Very Truly yours
Winslow Homer

Fig 60.
Adamson's Letter
of Introduction,
written by Homer
to his artist friend
Albert Kelsey

THE HOMER THAT I KNEW
by Alan Adamson

A short period of this artist's life that was known only to a few and about which little has been written in the pages devoted to a history of the man and a description of his work.

In the early part of the year 1881, if my memory serves me alright, there came to a small fishing village situated on the somewhat bleak coast of Northumberland, England, a stranger from across the seas whose presence in the village, coming, as it did, unheralded and for a purpose unknown, caused some little curiosity to be manifested among its dwellers. He differed a little in appearance from the ordinary run of folks that lived in the village, which consisted at that time mainly of people who gained a somewhat precarious livelihood from the sea, which, at this place, beats upon a rockbound coast, together with a few families of men engaged in business in some not far distant town that permitted a journey to be made by train to and fro daily, men who in this country would be called commuters but back there were termed all-the-year-round residents to distinguish them from the summer visitors.

I was born in the village, familiar with its people and surroundings and though, at the period of which I write it had become, in a minor degree, a place in the summer time to which visitors were accustomed to resort, it still retained much of the primitive aspect that it wore when the writer was old enough to take notice of anything that lay beyond the door of the house in which his folks had lived for years. The season of the summer migrants to the village had not yet arrived when the stranger of whom I write, made his appearance upon the scene so that about the only people who were astir and with whom he could enter into conversation or hold any communion were the hardy fishermen born and reared in the place.

Happening to be strolling along the sea banks that skirt the little fishing harbor of the village, in the evening hours of one day, I came across a friend of mine, like myself a resident of the village, in conversation with a man slightly unusual in appearance, wearing a rather short-tailed coat and a high silk hat, the latter a little the worse for wear.

The friend halted the writer and introduced to him the man with who he was talking as Mr Homer, an American, who but recently had arrived in the village. At that time I was a young man who had just thrown overboard a trade for which I had no liking and was at home, waiting for something else more suitable to come along, which as most people can realize doesn't come along very rapidly in a thickly populated country like England. Consequently, I had plenty of time hanging heavily, or otherwise, on my hands, and as Mr Homer seemed to be in much the same way situated, we then and there struck up a friendship which soon became one of a very warm nature and lasted for the course of a year or until such time as I crossed the Atlantic, having taken Horace Greeley's advice to go west and grow up with the country.

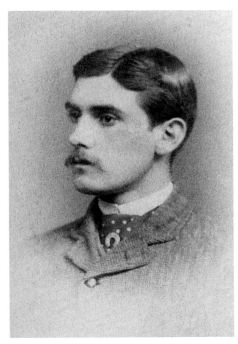

Fig 61. Alan Blythsman Adamson The photograph was taken on his 21st birthday in 1882, shortly before he travelled to the U.S.A.

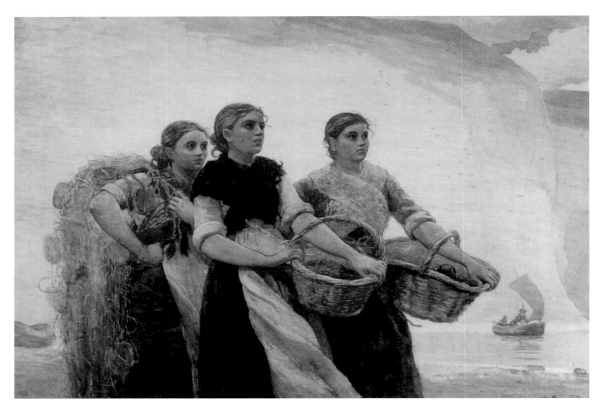

Fig 62. "A Voice from the Cliffs" - 1882
by Winslow Homer
Private Collection.

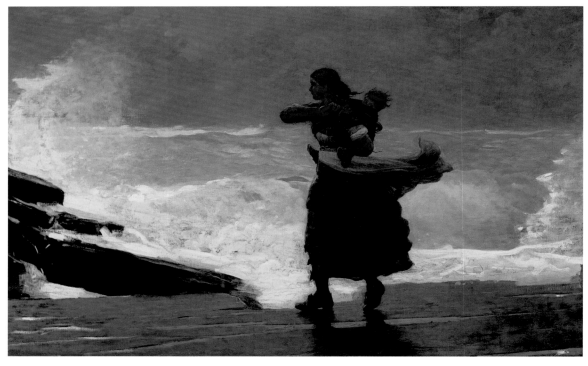

Fig 63. "The Gale" - 1882-93
by Winslow Homer
© *Worcester Art Museum, Worcester, Massachusetts*

My new found American friend told me that his name was Winslow Homer and that he was an artist who had come to England to find subjects for his brush different from those he had been accustomed to use in his own country. It was by mere accident he had chose the village of Cullercoats from among the many others in England that are better known to artists both English and American. On the voyage over he met a man, who, when Homer mentioned his object in crossing the Atlantic, told him to go to the village, I have previously named, where he would find just the subjects for his brush that he was seeking, at the same time giving him the necessary directions as to the best way of reaching the place of his recommendation.

The village is old and is situated on a part of the Northumbrian coast where the shoreline is much broken and the cliffs are bold and precipitous. For some years it had been the resort of artists of more or less fame, chiefly less until Homer came upon the scene. The features of many of its sturdy fisherfolks, have, nevertheless, by means of the brush of some of these artists, become fairly well known far beyond the confines of the village in which they were born and passed all the years of their life. Homer did not seem to care much about taking as his models the menfolks of the village, but chose rather to give an immortality to the faces and forms of the daughters of the men, who, in the days of which I write, before the coming of the steam-trawlers, were truly toilers of the deep. I think I am not claiming for Homer too much, when, in this connection, I use the word immortality, as a picture of a Cullercoats fishergirl he painted while a resident of the village, the one known as *The Gale*, which I watched with much boyish interest in process of execution, now hangs in the Worcester Massachusetts Museum, the sum paid for it being thirty thousand dollars. I also was frequently present in Homer's studio when he was painting *The Voice from the Cliff*, another of his famous pictures, which, if I mistake not, hangs in the gallery of a well known art collector and connoisseur of Philadelphia.

I remember well the departure of Homer from the village with these two pictures (and perhaps others that I do not recall) for London, to enter them in the exhibition of the Royal Academy. Homer was always reserved, not to say modest, never boastful of himself nor vainglorious about his abilities, but he did have a confidence in his art which was sufficiently pronounced to inspire his friends with the belief that he could attain the object he had in view for the nonce, at least.

As I have said, I was young at the time of which I write and Homer was then a man old enough to be my father. Youths are not at all times noted for a superabundance of tact or for an overplus of discretion. I do not in this instance believe that I was acting the part of a doubting Thomas, but shortly before he left on his journey to London, I said to him, "Homer, do you suppose that your pictures will be hung in the Academy?" He answered, "Of course they will be hung, I haven't the slightest doubt of it."

It must be remembered that the Homer of that day was not the Homer that he became after he returned to his native country from his visit to England. He was scarcely known in the art circles of the mother country. Nor had his own countrymen accepted him as one of the truly great among the painters their nation has produced. Undoubtedly, his visit to England was the turning point in his career. No more for him were the subjects to which he had devoted his brush in previous years, such as he found present in woods and by the streams of his own New England states, still less the negro mammies and their piccanninies, the latter with their sable faces half concealed by generous chunks of red ripe watermelon and such aspects of the placid, every day life as it exists in the interiors of Massachusetts and the Old Dominion state. For ever afterward he confined his genius to depicting the sea and those who go down to the sea in ships, especially at a time when its waters threaten most and are the least at rest.

Once I said to him, "Homer, what on earth made you cross the Atlantic from your own big country where subjects for your brush must be many and varied, and come to this little old world fishing village and be content to pass your days among perfect strangers?" "Atmosphere," he answered, "atmosphere and color." Then he went on to explain that there was much similarity about the people of his own country. If you saw one American you came pretty close to seeing them all. Leaving behind you one town you knew fairly well beforehand what the one you were approaching would be like in character and design.

"Look at the fishergirls," he said, "In this picture I am painting; there are none like them in my country in dress, feature or form. Observe the petticoat that girl is wearing," pointing with his brush at the one to which he referred, "No American girl could be found wearing a garment of that color or fashioned in that style."

Yes, Homer was looking for atmosphere and color and he found them both in this old world village in plenty. The impression made upon him lasted to the end of his days. He carried it back to America with him and all his work of the future is indelibly marked with its influence. Pictures he afterwards painted on the New England coast, such as *The Fog Warning* and *All's Well*, in their expression of form and feature, yes, even in their conception and treatment, show so much of a similarity to scenes with which he had become familiar on the old England coast as to be almost startling. The features of the men are the features of the Cullercoats fishermen, possibly a composite of those that he had known, the strong and full-bearded faces, the well poised heads set upon stalwart shoulders, the whole crowned with a sou'wester hat, are altogether too reminiscent of Cullercoats seafaring life to admit of any doubt being held in regard to the matter.

Homer made hundreds of sketches while residing in this north of England fishing village which he undoubtedly carried away with him when he returned to America. I have known him to spend half a forenoon showing them to friendly visitors. I remember on one occasion Homer and myself were standing in front of his picture *A Voice from the Cliff* in contemplation of the three fishergirls that are its dominant feature, when an artist, a native of the north of England and to the manner born, came into the studio and seeing us so occupied added his vision to those that were already being bestowed upon the canvas.

Presently he said, "Mr. Homer, you have achieved something which we artists are always striving after; you have caught the ideal."

I am unable to say whether or not Homer ever intentionally strove after the ideal. He certainly did not if the doing was in conflict with the true aspect of the subject that was presented to his eye or the faithfulness of the delineation he sought to convey to his canvas.

Homer has been depicted as a man of somewhat austere disposition, who loved to walk the lonesome path and follow the bent of his mind in remote places beyond the intrusion of the "madding crowd." He is said to have been unsociable, obsessed with the pursuit of his art and inclined to avoid the company of his fellowmen. He might have been so with some men of his own country, men immersed in their business life, with a constant itch to talk shop and run the gamut of their own inconsequential personal affairs in general. He never was so with me, possibly because at the time of our friendship I didn't have any business to talk about, nor any goods of that nature to retail. There were times when he would readily unbend and act with the spirit of a school boy. He was fond of walking and many a hike I have taken in his company along the shores of the North Sea, scrambling over its cliffs and floundering about on its slippery, sea-weedy rocks. He could play a good game of billiards, and frequently of an evening would be found in the billiard room of the hotel where he lodged, indulging with some of the villagers in that form of recreation. On rare occasions I have known him to join in the dance but I do not think he prided himself on his ability to shine on the polished boards of the dance room floor. Like most artists, he was an

inveterate smoker, seeming to have a preference for a pipe rather than for a cigar. He had quite a fund of humorous stories at his command and never displayed any hesitancy in their narration. In turn he seemed to enjoy listening to a good story well told. He had a sense of humor well developed which displayed itself in rather a broad manner on one occasion which I readily recall to mind. Staying at the village hotel at the same time as himself was a brother artist much in the decay who, if he ever had any ability to paint, it had long faded out and was now tattered and hanging in shreds. He painted a picture of one of the caves, plentiful enough on that coast, but being dissatisfied with his work, requested Homer to put in a few figures to give it a little more life and color. Homer responded by painting in the foreground of the picture the representation of a man garbed like a pirate, armed to the teeth of course, directing his footsteps toward the entrance of the cave, and staggering under the weight of a keg, filled with some kind of spirituous and ardent liquor that he carried on one of his shoulders. The sandy floor of the cave, or that part of it exposed to view, he strewed with dead men's bones.

Homer had not long been in the village before he discarded his tailed coat and tall hat and for the remainder of his stay usually went about the place in a fisherman's blue woolen jersey and a nondescript felt hat. Indeed the tall hat came to a sad end shortly after his arrival in the village as, failing, one day to lower his head sufficiently while going through an ancient and dilapidated passageway, there was little left of his most distinguishing adornment except the brim when he emerged from the gloom of the passageway's grimy interior.

Homer's works were not rated in those days at anything near the price they now readily command. Like many another genius in the world of art, fame came to him late in life, but happily, in this instance, not too late for him to share with his fellow-countrymen the satisfaction and pride engendered by its attainment. I am writing after more than forty years have lapsed since I roamed the banks of the North Sea in company with Winslow Homer, but the impression I got from him at that time was that for the best of his pictures he did not expect a price that went beyond three or four thousand dollars. I distinctly remember that at the time of a storm which broke on the coast of Northumberland he made a sketch of a vessel that had gone on the rocks and exhibited it in the window of an art dealer in Newcastle-upon-Tyne. For this sketch he was asking not to exceed one hundred and fifty dollars.

I am probably the only man in the United States who knew Winslow Homer during the time of his stay in England. The men of the village with whom he associated, being all considerably older than I, have undoubtedly passed on. The fishergirls he depicted are now in the sear and would no longer be attractive to an artist's eye. At least to the one looking for youth and comeliness in his models. The village itself is radically changed, made sanitary and modernized in other respects and it no longer has the picturesque aspect that was its charm when Homer watched from the cliffs, on which it stands, the morning's incoming boats crossing the harbour bar and the wives standing on the beach awaiting their husbands' return.

A few years after Homer left the village, most of its men who still continued to follow the seafaring life, found it more profitable to engage their services with the steam-trawlers that pursue the fishing industry on a larger scale and in a more systematic manner. Alas, the glory that was of the village has gone, never to return. But then, what says the ancient sage? It is not, "Sic transit gloria mundi," which classic aphorism however I have never found much of a source of comfort. It was simply in this instance a case of survival of the fittest, the inability of the hand-baited fish line to compete with the trawl net.

Homer has been called the greatest of American painters. On this matter I am unable to express any worth-while opinion, because since my residence in America my lot has been cast mostly remote from its art centres and all that pertains to the artist and his life. But if in the sound and unbiased judgement of men qualified to speak with the authoritative voice, Homer is thought worthy of being proclaimed the greatest American painter, then not the least among the events of his life that contributed toward gaining for him this coveted position was the year or two he spent in the little old world fishing village on the Northumberland coast, painting its fisherfolks and hobnobbing in general with its people.

In the first of my journeys over the wide stretches of the North American continent, shortly after I sought admittance through its gates, I stopped for a brief half hour or so in one of its large lake cities which I need not particularize further than to say that it was well known to every English youth, such as I, as being a center of the nation's meat packing industry. I wrote back to my folks that I could see little that was attractive about the city and that it left no more impression upon me than a row of pigpens. They showed the letter to Homer and it was the innocent cause of ending a beautiful friendship. He probably jumped at the conclusion that I was decrying the architectural features of his country. If we ever met again, undoubtedly he would have forgiven me readily. But an inexorable fate ruled otherwise. I should have known better than to commit any such solecism but I was young and brash at the time and without the discretion that comes with the more ripened experience of older years. I have long since learned that if you would view an American city aright you must view it from some more favorable vantage point than from a passenger train or railroad terminus in the vicinity of which latter structure cattle yards and hog pens sometimes dominate the landscape.

Fig 64. Alan Adamson in 1900

All the same I can look back through the distant years to the days I walked and talked with Winslow Homer with a great amount of satisfaction and pleasure. I am always more than pleased when I read in the literature of his country, which for the past forty years has also been my country, appreciative notices of his life or work, or to learn that some one or other of his masterpieces has been secured for one of his nation's most frequented public galleries to rivet the attention of even the most casual and superficial of observers because of the fact that "a thing of beauty is a joy forever," and also that "beauty of itself doth persuade the eyes of man without an orator."

Alan Adamson's story gives a rare and interesting glimpse of Winslow Homer's more private side. There is nothing here of the solitary and even anti-social impression that has generally been conveyed by his biographers. Adamson reports a man who welcomed criticism of his work, was not adverse to helping his fellow artists, and entered into the social life of the village. The image of reclusiveness, lonesome pursuits, and uncordiality, which has some accuracy apparently, with respect to Homer's later years according to his biographers, is an image that would have surprised Cullercoats folk.

Another of Homer's friends from the middle class was William Cochrane, a wealthy coal owner who lived at Oakfield House, an imposing Victorian residence in Gosforth, a suburb of Newcastle upon Tyne. Born in Staffordshire in 1837, Cochrane came to the North East in 1857 to manage and open out collieries that belonged to his father. These were at New Brancepath, which he sunk, Tursdale and, perhaps the most famous, Elswick colliery. He took a great interest in the North of England Institute of Mining, becoming a member of the Institute council and eventually its president. Cochrane was also benefactor of the Durham College of Science, All Saints Church, Gosforth, and the Fleming Memorial Hospital. He was passionately fond of music, being a skilful violin player. In 1887 he formed the Chamber Music Society in Newcastle upon Tyne and took a leading roll in many concerts. His interest in art led him to become a patron of such local artists as Robert Jobling and H.H. Emmerson, and in 1881, of Winslow Homer.

As a regular visitor to Oakfield House, Homer built up a close relationship with Cochrane. Cochrane had much advice and encouragement for his artist friends and it was perhaps at his suggestion that Homer submitted a work to the autumn 1881 exhibition of the Newcastle upon Tyne Arts Association. Cochrane was a member of the sponsoring committee.

In December 1881, Cochrane purchased *A Fishermans Family Awaiting the Return of the Boat* from Homer. A letter from Homer to Cochrane dated 21 December 1881 states "I am very glad that you like it. I enclose the bill as you request."[20] Cochrane died on 25th November 1903 and Oakfield House, together with its furnishings and effects, passed into the hands of his nephew, Sir Cecil Cochrane. Following Sir Cecil's death in September 1960, the Homer watercolour entitled *A Fisherman's Family Awaiting the Return of the Boat*, which had hung at Oakfield House since 1881, was sold at Sotheby's London for £5,600 to Mr John Nicholson, the New York dealer, and is now in a private collection. In 1983, Marion Angus told me that her parents had been close friends of Sir Cecil Cochrane, and that she had visited Oakfield House on many occasions. She recollected that *A Fisherman's Family* had adorned the wall of the dining room along with another painting by Homer. Sir Cecil had told her that Homer had given it to William Cochrane shortly before he left England, as a token of their friendship. The whereabouts of the second watercolour Homer presented to Cochrane, a work unidentified by title, is unknown.

Homer was also acquainted with Lord Armstrong, the successful Victorian industrialist who established his armaments, shipbuilding, and engineering business at Elswick in Newcastle upon Tyne in the mid-nineteenth century. Armstrong was also a patron of several local artists, most notably of Henry Hetherington Emmerson, who as well as residing at Rothbury in Northumberland adjacent to Lord Armstrong's Cragside residence, owned a house at 44 Beverley Terrace, Cullercoats, where he visited often and finally took up permanent residence in 1888. Many of Emmerson's paintings still hang on the walls of Cragside, now owned by the National Trust.

Fig 65. William Cochrane *Fig 66.* Lord Armstrong

It is possible that Homer was introduced to Lord Armstrong by Emmerson, but more likely that the introduction was made through the Adamsons. Lord Armstrong was acquainted with William Adamson, and is known to have visited him at Garden House in Cullercoats. His son, Alan Adamson, became apprenticed at Armstrong's Elswick works, and was employed there until shortly before he first encountered Homer in 1881. It is not known if Lord Armstrong purchased any of Homer's paintings, although he did have a reputation for entertaining visitors from abroad, and visited many art exhibitions including those organised by the Newcastle upon Tyne Arts Association, at which Homer was represented by his one work in 1881.[21]

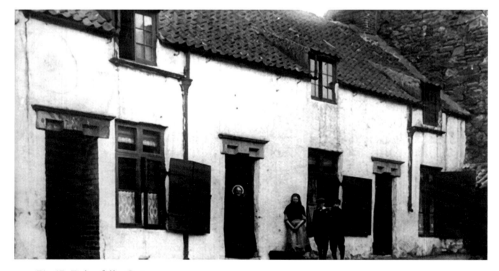

Fig 67. Fisherfolks Cottages,
Cullercoats

There has been much speculation about whether Homer returned to the United States for the winter of 1881-1882. Lloyd Goodrich noted in 1944 that Homer seemed not to have painted any pictures then and, because it was unlike the artist to endure long periods of inactivity, he may have returned briefly to America.[22] Further, Cullercoats is a dark, cold place in mid-winter, inconducive to art. Philip Beam contended in 1966 that if this conclusion is correct, it provides a solution to the puzzle of Homer's watercolour *Marine*. Beam has established that both *Marine* and another work, *Observation on Shipboard*, in which the same vessel is depicted from the opposite viewpoint, show the Parthia's deck. He states, "Homer was not prepared to paint this picture when he sailed abroad in 1881, or judging by his summer output, prior to the time when the autumnal storms of that year opened his eyes to the power of the sea and enabled him to paint the *Wreck of the Iron Crown*... but he was ready to paint *Marine* at anytime after that autumn, and it is extremely probable that he painted it as a consequence of a midwinter trip to America such as Goodrich has proposed."[23] On 1 September 1881 the Art Interchange stated that Winslow Homer was expected back in the U.S.A. shortly.[24]

No other evidence is available, for as William H. Miller, the steamship historian said, in a letter to Beam, "All of the great steamship lines, such as Cunard, have long since discarded their records."

But while this is true, the Marine Intelligence and Shipping columns of both the *New York Times* and the *Liverpool Daily Post* include details of the first class passenger list on sailings to and from the United States and from these I am able to establish with whom Homer sailed to England in March 1881 aboard the Parthia and returned in November 1882 on the Catalonia. But a scanning of the passenger lists published in these newspapers has not revealed Homer's name at any point between these two. That Homer ceased to paint in Cullercoat's during the midwinter of 1881/82 is evident from his work, and the correspondence that he had with his New York agent, J. Eastman Chase, sheds a little further light on his activities of those months. Four letters exist, written by Homer in Cullercoats. The first is dated 7 October 1881 and advises Chase that by 1 November, Homer will have sent him some watercolours "large size and price." Homer also asks Chase the value of a painting by Corot that he claims to have picked up for the princely sum of five shillings, telling him that if he can sell it for around one thousand dollars, he will send it to him!

The second letter is undated by Homer but written on it in another hand is "Winslow Homer 12/81." It is fair to assume that this is when the letter was received by Chase, its receipt recorded on the letter by him or an assistant.

Since mail at that time took between two and six weeks to cross the Atlantic, this letter would probably have been posted by Homer in Cullercoats sometime during November 1881. It informs Chase that Homer has sent him c/o his relative Mr. Samuel T. Preston of 89 Gold Street, New York, some thirty watercolours together with an invoice for them. Homer states that he is prepared to pay for two weeks advertising in any two papers, but leaves it up to Chase to decide how to mount them. He asks for payment cheques to be sent to S.T. Preston.

The third letter is again undated by Homer, but it was received by Chase in New York in February 1882. Homer tells Chase that he has sent his painting of the *Wreck of the Iron Crown* by mail and that his asking price is $250. The fourth and final surviving letter from this period is dated 5 March 1882. In it Homer thanks Chase for his "great judgement" in arranging the exhibition of his sketches. He also tells Chase to stop all sales of paintings as he proposes making a "corner" in his work by giving everything not sold away to where it will never come on the market again.[25]

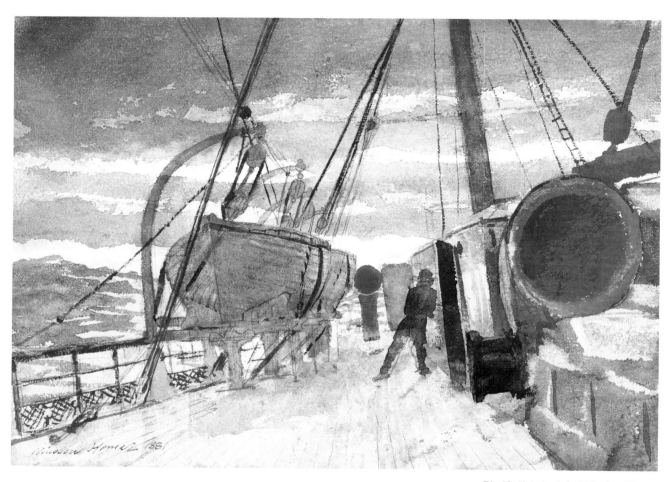

Fig 68. "Marine" by Winslow Homer
© *Bowdoin College Museum of Art*
Brunswick, Maine

From these letters we can deduce that after sending the thirty watercolours to Chase in November 1881, nothing more was forwarded until *Wreck of the Iron Crown* was sent in February 1882. The apparent delay in sending *Wreck of the Iron Crown*, (the shipwreck occurred on the night of 20/21 October 1881), was due to the fact that Homer had had the painting displayed in the window of a Newcastle upon Tyne art dealer. We also know that George Horton saw Homer in the village sometime after the *Iron Crown* disaster, probably mid-November, as it was unlikely that Horton and Ogilvie would have been working at St. Mary's Island much later than this.

Accordingly, Homer appears to have been inactive as an artist, and perhaps also away from the village, from late November 1881 until February 1882. If he had intended to return to the United States surely some indication would have been made in his second letter to Chase? It is also probable that Homer would have taken the 30 watercolours back to the United States with him, rather than entrust them to a shipping agent.

A clue of a different kind to Homer's whereabouts during the winter of 1881/82 was uncovered in 1976 by David Tatham when he made the first examination of a group of books that were known to have been in Homer's possession. In the group, now owned by the Margaret Woodbury Strong Museum in Rochester, New York, is a copy of F. E. Feller's *A New English and French Pocket Dictionary Vol. I English-French*, published in 1879 by Dulau & Co. in London.[26] The book contains a bookseller's label for "W.E. Franklin / Newcastle on Tyne." Franklin was a well-known bookseller with a shop at 42 Mosley Street, Newcastle, and the fact that Homer purchased the dictionary while in England would, as Tatham has suggested, indicate that Homer, at the very least, contemplated a trip to France during his stay at Cullercoats. Unfortunately, passenger lists and records of shipping between England and France are much less complete than those for ships on the Atlantic Routes, and I have not been able to document whether Homer made a trip to France in December 1881.

No passenger routes from the Tyne to France existed in the 1880's, although some of the merchant ships had limited accommodation available to passengers, usually no more than six to ten bunks. These sailings were to Boulogne and, less frequently, to Calais and Dunkerque. The journey would have been quite lengthy, around twelve hours or more, and the accommodations would have been spartan. If Homer went to France, it is much more likely that he travelled by train from Newcastle to London and then on to one of the Channel ports where a short, comfortable passenger service to Calais or Boulogne was readily available. A check of the immigration records for 1881/82 served only to reveal their poor state; they are almost non-existent.

If he went to France, he very probably visited Paris. He may have looked up some of the people he had known during his ten month visit in 1867. But he may not have gone alone. There is some reason to think that Homer's brother Charles and his wife visited Homer in Europe in 1881 or 1882.[27] A rendezvous in Paris would have made more sense than a gathering at the edge of the North Sea in December.

On balance, I think that Winslow Homer spent those "lost" few weeks in the winter of 1881/82 in Paris and not New York. Alan Adamson makes no mention of Homer leaving the village that winter, but perhaps he did not consider it important, or perhaps he just forgot about it. Maybe evidence will some day appear to settle the matter.

Fig 69. The mouth of the River Tyne with
North Shields Fish Quay in the foreground
Photo: Peter R. Hornby

Fig 70. The Groyne Light, Tynemouth
Photo: Peter R. Hornby

THE IRON CROWN SHIPWRECK

The wreck of the *Iron Crown* was the most dramatic event witnessed by Homer while he was in England. It occurred on the night of 20/21 October 1881 at the mouth of the river Tyne on the notorious Black Midden Rocks. These rocks had claimed many ships. Their loss, with their crews, led to the building of the first boat designed for the specific purpose of saving lives. Following the loss of the crew of the ship *Adventure*, in September 1789, a committee was formed and a prize offered for the best design of a lifesaving boat. William Wouldhave's entry was selected and on 30 January 1799 the first lifeboat, aptly named the *Original*, was launched. The manning of this and other lifeboats was often through makeshift arrangements for many years, however. Then, in November 1864, the *S.S. Stanley*, caught in a gale, struck the Black Middens and was wrecked just 200 yards from the shore, with the loss of 26 passengers and crew, while hundreds of able-bodied onlookers stood by watching helplessly.

Following the wreck of the *Stanley* a public meeting was held and the Tynemouth Volunteer Life Brigade was formed on 5 December 1864. It was composed of a band of volunteers who were trained to use the Rocket Apparatus with the intent of assisting the Coastguards in times of emergency. This was the first organisation of its kind in Britain.

Four days after the establishment of the Tynemouth Brigade, a meeting was held in Cullercoats and the second Volunteer Life Brigade was formed.[28] This led to the formation of some 350 similar organisations elsewhere in the country.

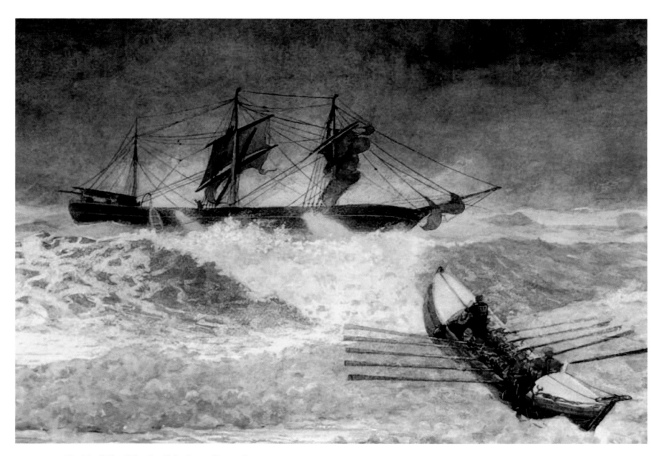

Fig 71. "The Wreck of the Iron Crown"
by Winslow Homer
Collection of Carleton Mitchell.
On extended loan to
The Baltimore Museum of Art

Fig 72. Robert 'Scraper' Smith

Homer was acquainted with a man who had joined the Brigade in 1870 and in time became the most famous of all the Coxswains of the Tynemouth Lifeboat. This was Robert Smith, affectionately known to his friends as "Scraper." [29] He was born on 12 July 1849 and lived at Garden Square, Cullercoats. As a child he attended an old Quaker school in the village where the main subject was spelling and the fee was one penny per week. Robert liked to help his father, and when he was still quite young, it was not unusual for him to be seen walking up the coast to Hartley where he would collect limpets for baiting his father's lines. He was, in fact, only twelve when he joined the crew of a fishing boat.

The wreck of the *S.S. Stanley* on the Black Midden Rocks at Tynemouth in November 1864 decided Robert Smith's future. With other fishermen, Robert, then fifteen, had watched helplessly as heroic but unsuccessful efforts were made to save the men from the wreck. He could not put their cries for help from his mind and became determined to join the Lifeboat Service as soon as he was able to pull an oar. He joined in 1870 and spent some fifty years in the Service, retiring in 1920 at the age of seventy-one after having served as Coxswain for the preceding ten years. From the first motor lifeboat, the *Henry Vernon*, he commanded the epic rescue from the hospital ship *Rohilla* off Whitby in 1914. But an earlier, successful rescue attempt, in which Robert Smith was a member of the lifeboat crew, was one observed and painted by Homer, the shipwreck of the *Iron Crown* in 1881.

Gordon Hendricks quotes local newspaper reports of the shipwreck. He attributed them to the *South Shields Daily Standard*, but in fact this newspaper ceased publication on 5 March 1881. Presumably Hendricks extracted the reports from the *Shields Gazette*. However, he appears to have mixed reports on two different shipwrecks that both occurred on the night of 20/21 October 1881.[30]

Fig 73. The Inside of the Tynemouth Volunteer Life Brigade Watch House

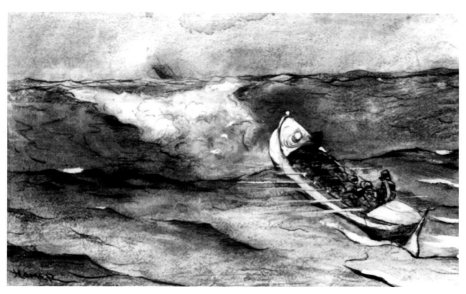

Fig 74. "Life Boat (Wreck of the Iron Crown)"
by Winslow Homer
© *Cooper-Hewitt National Design Museum*
Smithsonian Institution, New York

The first of these was the wreck of the *Bertha*, which entered the mouth of the River Tyne at about 11 p.m. during a gale and went ashore on the Herd Sands at South Shields. Later, at about 12.30 a.m. the *Iron Crown* entered the river and got into difficulties. The story is best told by relating the whole of the report from the *Shields Gazette* of Saturday 22 October:

"The Gale continued to blow throughout last night, from the south east, varying at times to due east, with heavy blustering squalls. All yesterday and throughout the night a vigilant lookout was kept at the Tynemouth Brigade house.

At about half past twelve o'clock (midnight) the green light of a sailing vessel was seen, as if in proximity to the staging at the south pier. In response to signals of distress immediately sent up from the vessel, the guns at the Spanish Battery were fired, and the usual alarm given from *HMS Castor*, that a ship was on shore at the south side. The vessel, however, was observed to be drifting towards the north pier, she went straight for the bend near the outer end, and then struck, according to one testimony, but immediately drifted out into deep water. Here the anchor was let down, and the vessel rode, where she still lies, a little further out to sea than the new landing stage for the pier ferries. As soon as it was seen that the vessel had come over to the north side, the guns were fired announcing this fact. People who heard the reports at Tynemouth believed that a second vessel had gone ashore, and it was some time before the crowd which had gathered on the pier, knew the real state of affairs. Mr. John Anderson had the van with the rocket gear taken along the rails on the lower pier to a point opposite the ship. There was a strong force of members of the Brigade. Mr. Lutter took command of the operations. Several rockets were fired from the vessel with her head to the sea. In the shortest possible space of time, a rocket was fired from the pier, which went a little high, and was apparently carried to leeward by the strong wind blowing at the time. The ship continued to send up rockets, and it was seen that the line had not reached the hands of those on board. A second rocket was immediately fired, it went straight amidships, barely clearing the bulwarks to all appearances, and laying the line across the deck. All this was the work of only a few minutes, and was conducted amidst the growing excitement of the gathering crowds who were still uncertain how great the danger

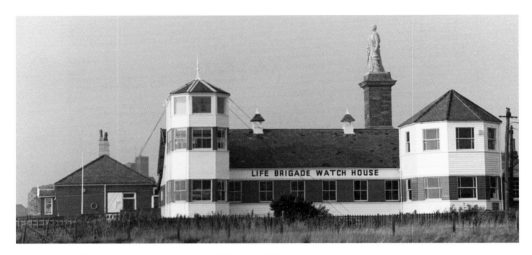

Fig 75. Tynemouth Volunteer Life Brigade Watch House today

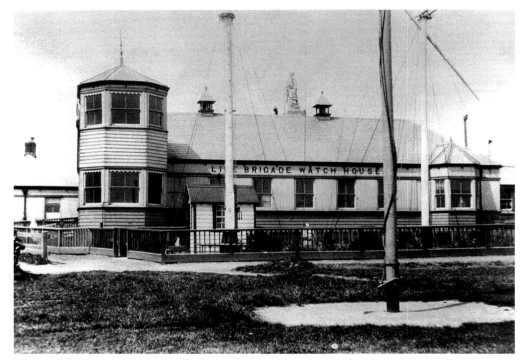

Fig 76. TVLB Watch House in the 1930's
North Shields Central Library

might be. It was not known that the vessel was anchored. It was thought she might be fast amidships, she could be seen rising and falling with the waves. The weather, which had cleared a little, again grew thick, and with the waves breaking over the pier upon the Brigadesmen and spectators, the fate of any craft out there in the storm did not seem enviable. There appeared to be some delay on board in taking advantage of the means of escape offered them. In addition it was found that the whipline of the hawser had got jammed in the block, and great difficulty was experienced in getting it free. The strong range carried the line landward, and they seemed to get entangled. The ship was so great a distance from the shore that the waves had great power over them.

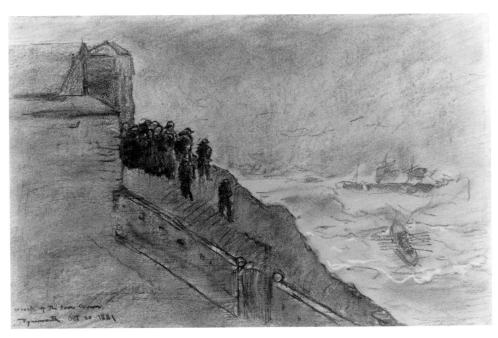

Fig 77. "Drawing for the Wreck of the
Iron Crown" by Winslow Homer.
Collection of Carleton Mitchell.
On extended loan to the Baltimore Museum of Art

Meanwhile, a scene of great excitement and perseverance was proceeding in the Haven, where the most strenuous efforts were in progress to launch the R.N.L.I. lifeboat *Charles Dibden.* Whenever the craft was pushed afloat, the waves caught her and threw her broadside on the sand. From twenty-five to thirty men struggled there for upwards of an hour to get the boat afloat. They waded in waist deep, they risked being carried off their legs by the incoming seas, or sucked into deep water by the receding wave. The foam covered water, lighted up by their lanterns, looked like a great sheet of white snow, in which dark figures dressed like Esquimaux plunged about, mid shoutings heard far above the noise of the storm. Strong men left their coats and upper garments in the hands of the fringe of patient watchers, who stood as spectators on the sands, and plunged in, each in the certain hope that if his hands were on the boat, they would defy wind and wave. But the strongest force of men that could flex themselves in any way about the craft could not prevent her swinging round as the sea struck her. The yielding sand made effort difficult and dangerous. This was a gallant struggle and was in the end victorious, but not until different tactics had been tried. A rope was fixed to the boat, and carried along the line of the pier, and she was thus literally pulled out to sea.

The Brigadesmen were, meanwhile, extracting their lines from the entanglement. They had effected communication with the ship, sometime before the lifeboat was got off. When it was seen that the gear had been fixed all right, a strong force of men were put on the hawser, which was drawn through the block, and carried along the upper pier. A red light over the ship's side soon showed that someone was in the cradle, and after vigorous pulling a figure was seen rising up from the surf into the light, and in a moment amid cheers, the first of the crew had been landed, he was a boy, and taken charge of and led to the Brigade house. In quick succession four more of the crew were landed. The fifth to come ashore brought a message from the Captain to say he desired to send his wife ashore next, and special efforts were made by tightening the hawser to make the journey as comfortable as possible. By this time it was seen that there was no immediate danger to the vessel breaking up, but this incident promised to add a new interest to work which was trying the endurance of many of those engaged in it. To hold on by that hawser, with the waves rising and falling in cascades from the back of the pier, was no easy task.

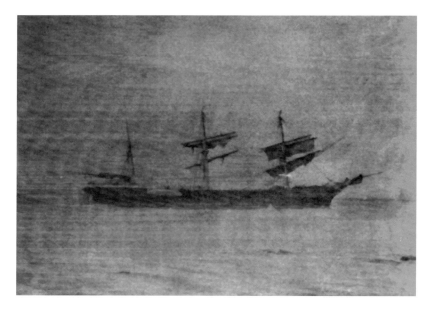

Fig 78. Photograph of the Iron Crown marooned on the Black Midden Rocks

When the cradle was sent back, however, for the sixth time, there was a pause, and it appeared that the lifeboat had reached the vessel's side, and was taking off the rest of the crew. Seeing that there were 22 persons in all, this was a great relief, both as a matter of safety, and a matter of time. A portion of the Brigade now turned their attention to the loading of the boat which was seen making for the Haven. In response to a cry from someone on board for assistance, on the sands, a rush was made in that direction, and soon, what was believed to be the remainder of the crew, with the Captain and his wife, were safely landed. Captain James and his wife were conveyed in Dr. Wilkinson's carriage to Mr. Bruce's Temperance Hotel. The lifeboat waited fully quarter of an hour alongside the ship, and then was obliged to pull off, as they were in a perilous position, having the full range of the sea on their beam. Immediately those rescued were landed, it was found that two of the crew were still on board; one named Carl Hof, and the other William Stieglits, the lifeboat did not return to the vessel, and the men were on board up to eight o'clock in the morning, apparently all right."

Fig 79. The Lighthouse on the
North Pier at Tynemouth
Photo: Peter R. Hornby

Fig 80. Tynemouth Yacht Club members
beaching their boat in Tynemouth Haven
Photo: Peter R. Hornby

A later report for the same date states, "The Ship *Iron Crown*, has driven ashore on the rocks under the Spanish Battery. A lifeboat put off at eleven o'clock this morning and took from the vessel the two of the crew which were inadvertently left on board last night."[31]

When the shipwreck occurred at 12.30 a.m. on that wild and windy October night, Homer was no doubt in his bed in his lodging about two miles from the scene. By morning word would have reached Cullercoats that a ship was aground on the Black Middens. It would not have taken Homer long to hear the buzz that would have been going around the village. He hired a cab and made for Tynemouth Haven and the Spanish Battery.

William H. Gerdts questions the fact that Homer actually witnessed the shipwreck of the *Iron Crown*.[32] But there is no doubt that Homer watched the final rescue attempt which took place at 11 a.m. on 21 October when the remaining two crewmen were rescued. An eyewitness to this fact was the North Shields painter George Horton:

"I have seen many wrecks on our coast in 50 years. It is a strange feeling when you are lying in bed in the early morning and you hear the guns go off for a ship on the rocks and people begin to thud past your window... men in sou'westers and sea-boots bound for the Brigade House... Early one morning in Tynemouth Harbour... an iron clipper-built ship, the *Iron Crown*, was lifted by tremendous seas and crashed on the rocks. As I stood watching the rescue operations a little cab turned up with an old Cullercoats fisherman on the dicky. Out stepped a dapper, medium sized man with a water-colour sketching book and sat down on the ways. He made a powerful drawing with charcoal and some pastel, the sea grey green and the rest brown tone and in the middle distance sea he set the lifeboat.

"How I discovered his identity is quite a different sort of story. It happened that one morning Fred Ogilvie, the water-colourist, and I were going through Cullercoats on our way to St. Mary's to work when just when we were behind the Huddleston Hotel, who should run out of Brown's butcher shop but the painter of the wreck. He was a picture himself. On his head was an enormous blue Tam o' Shanter with a red top-knot, in his hand was a swinging bullock's heart. "Come on" said Ogilvie, "That's Homer! Get out of his way or we'll never get anything done. When he's in that state he'll keep us with him all day!"[33]

Scraper Smith, who played an important role as one of the lifeboat crew who assisted the *Iron Crown*, later became Harbour Master at Cullercoats for some twenty years and could often be seen at the Watch House gazing out across the bay. If ever there was a risk of danger to anyone, the shrill sound of his whistle would alert them immediately. He was a staunch Methodist and was a member of the Cullercoats choir for over fifty years.

During his lifetime he received many medals, but the highest recognition of his gallantry was when he was presented with the Empire Gallantry Medal in June 1924 by King George V. However, as he was almost blind by this time, due to the years and years that his eyes were subjected to the onslaught of the salty sea water, he failed to recognise the King at the presentation ceremony, and this was a fact that saddened him for the rest of his life.

Homer often used the Cullercoats Life Brigade Watch House as a background to his work. This building, built in 1879, still dominates the Cullercoats sea front today. Although now only used as a fishermen's clubhouse, it is a reminder of the days when men's lives depended on the watchful eyes of the volunteers who daily manned its frontage watching for the "Perils of the Sea."

Fig 81. Cullercoats Volunteer
Life Brigade Watch House today

Fig 82. Cullercoats Volunteer Life Brigade
Watch House in the 1930's
North Shields Central Library

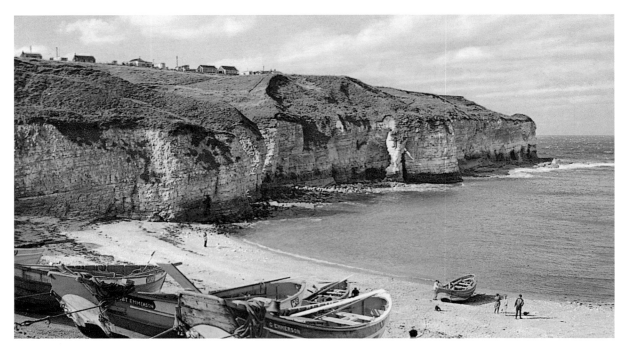

Fig 83. Flamborough Head today

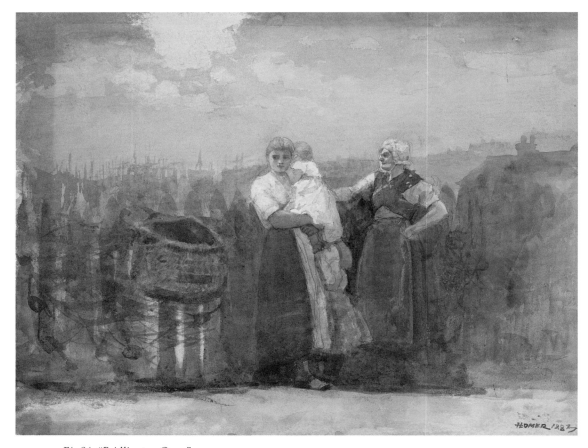

Fig 84. "Bridlington Quay"
by Winslow Homer
© 2003 Museum of Fine Arts
Boston, Massachusetts

A TRIP DOWN THE EAST COAST

During his stay in Cullercoats, sometime in the summer of 1882, Homer took a trip down the East Coast to North Yorkshire and produced several paintings en route. The figures of Cullercoats fisherfolk that appear in some of these works are presumably later additions, made when he returned to his studio. Little is known of this trip or the reasons why he decided to make it, though sight-seeing on this part of the North Sea was common enough, for there is much fine scenery. There has been some speculation that he made this journey to visit Frank Meadow Sutcliffe, the famous Whitby photographer, or perhaps James Russell Lowell, the American poet and fellow Bostonian who was the American Ambassador to England at the time, and had a summer residence in Whitby. It is possible that he went to visit George du Maurier who also summered in Whitby that year, and both of them were friendly with Sutcliffe. A measure of Sutcliffe's friendship with the popular novelist and illustrator is the fact that he kept a copy of du Maurier's *Photographing the First-born* on his studio wall. Though du Maurier would never agree to sit for Sutcliffe, Lowell visited Sutcliffe's studio on several occasions and sat for a portrait photograph.[34]

Fig 85. James Russell Lowell

George du Maurier had joined the staff of *Punch* magazine in 1864 and soon demonstrated his mastery of comic illustration as a serious art form. From his summers at Whitby during the 1870's and 1880's came many illustrations of fisherfolk. It is possible that Homer saw these illustrations and recognised that du Maurier, like himself, had developed an affectionate kinship with these rugged inhabitants of the North East coast. But in fact the only evidence of Homer's interest in du Maurier's work is his copy of du Maurier's novel *Trilby* into which he pasted a portrait of the author cut from some unidentified newspaper.[35]

Frank Sutcliffe's photographs were very popular in England at the time of Homer's visit in the early 1880's and his work was seen in many shops and exhibitions in Newcastle upon Tyne and elsewhere. It is unlikely, however, that Sutcliffe's photographs of fisherfolk would have had any influence on Homer, since being resident in Cullercoats, he already knew the fisherfolk firsthand. If the three of them ever met Homer while he was in England, the venue would probably have been James Russell Lowell's residence in Whitby. Homer had illustrated a gift book edition of Lowell's *The Courtin* in 1872 and each of these Americans surely knew each others work.

It is true that no Homer paintings or drawings of Whitby or its populace are known. Whitby was, and indeed still is, a bustling fishing port which had many similarities to Cullercoats. Its fisherfolk were depicted by Sutcliffe and du Maurier. If Homer did spend some time in Whitby, the conditions of time or place may have kept him from working there. Instead, he utilised his artistic talents some twenty miles further down the coast at Bridlington and Flamborough Head.

It is possible of course that he by-passed Whitby and went directly to Bridlington or Flamborough. It is not known whether or not Homer visited Staithes near Whitby where a renowned and thriving art community flourished. Perhaps one day documents will be found that will throw some light on this journey. His main objective may have been the simple one of seeing whether there were subjects for him to paint more interesting than he

found in Cullercoats. He also ventured northwards, as is evident from his painting of Blyth Sands. Blyth is a few miles along the coast to the north of Cullercoats.

According to interviews with Homer published following his return to the United States, he also travelled to other parts of the U.K. including Scotland and Wales. I can find no evidence to confirm this, but there is no reason to suppose that he did not. As a visiting American, it would be quite natural for him to want to do a spot of sight-seeing whilst in the U.K., and perhaps also to take the opportunity to see if there were any more suitable locations for him to exercise his artistic talents.

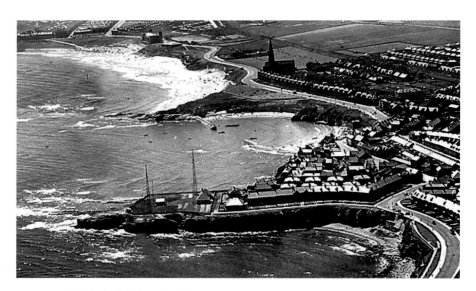

Fig 86. Aerial view of Cullercoats

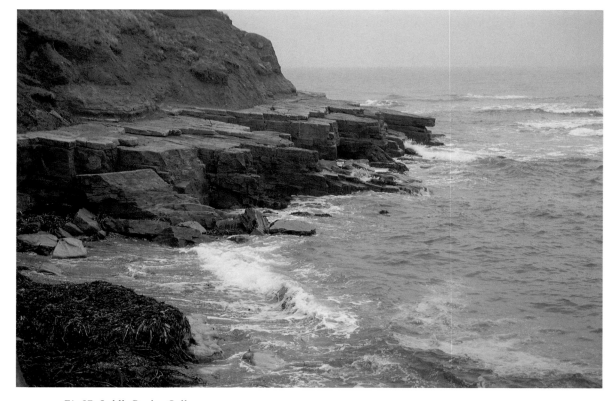

Fig 87. Saddle Rocks, Cullercoats
Photo: Peter R. Hornby

Homer left England on Saturday 11 November 1882 aboard the *Catalonia* from Liverpool.[36] He Arrived in New York on Thursday 23 November 1882.[37] His English work was highly praised when he exhibited it. In 1883 he moved to Prout's Neck on the coast of Maine, where he converted a carriage house into a studio-cottage and this was his home for the rest of his life. He died in his studio after an illness of several weeks, on 29 September 1910 at the age of 74.

Fig 88. Homer's Studio at Prout's Neck
Photo: Peter R. Hornby

Fig 90. Chris Wright, A member of the Cullercoats Lifeboat Crew, wearing a present day life jacket

Fig 89. Andrew Taylor, Coxwain of the Cullercoats Lifeboat from 1869 to 1898

Fig 91. The Coble "Gratitude" (BH452) One of the remaining cobles that still fish out of Cullercoats Bay

CULLERCOATS TODAY

When Winslow Homer arrived in Cullercoats in the spring of 1881, he found there a thriving fishing community which was not far off reaching its peak in the late 1880's.

The fishing fleet numbered around 130 cobles in 1881, but today there are only 3 cobles remaining in Cullercoats manned by hardy fishermen who sail out of the bay to earn their living. These are the SN 7 James Denyer, BH 84 Crystal River, and BH 452 Gratitude. Watching these folk at work, and conjuring up images in one's mind's eye of what it must have been like in Homer's day, it is easy to understand and appreciate how Homer became fascinated and enamoured with the way of life of the fisherfolk that was so different to what he had been used to back in the USA.

Much redevelopment has taken place since Homer's day. Gone are the fishwives and the quaint fisherfolks cottages, but the beach with its two piers and the Life Brigade Watch House still remain as a reminder of the days when the sea ruled the lives of the village's inhabitants.

Many of the features that Homer depicted in his paintings are still identifiable today. Table Rocks, Brown's Point, the crescent-shaped beach, Beacon Rocks and the Beacon itself; the North and South Piers, and of course the Life Brigade Watch House which he included in many of his paintings. The present Lifeboat boathouse, funded by the Co-operative Wholesale Society, was built in 1896 and still stands below the Watch House at the rear of the beach above the water line. Although the original rowed lifeboats and subsequent motor lifeboats have now been replaced by an inflatable inshore lifeboat, the courage and commitment of the present day crew has not been diminished by the passing of time.

In 1881 the 10 oar lifeboat "Palmerston" was on station in Cullercoats Bay where she served from 1866 until 1884. She was built at a cost of £275.00 and donated by Peter Reid of the London Stock Exchange. During her eighteen year career at Cullercoats she was credited with saving 65 lives.

The village has much changed since the 1880's, with most of the old fisherfolks cottages being demolished in the 1960's and 70's to make way for newer developments. Fortunately during the 1970's redevelopment, the local authority decided to preserve one side of one street of the fisherfolks cottages that so epitomised the fishing community of earlier years. Simpson Street today, stands as a lasting memorial to the village's history as a hard working fishing community.

The Bay Hotel (formerly the Huddleston Hotel) still occupies its commanding position overlooking the bay much as it did when Homer first occupied a room there after his arrival in the village in 1881. Sitting in the bar/lounge and enjoying a good meal and stimulating chat about "the old days" in pleasant surroundings with many of the retired fishermen who now frequent the establishment is an enjoyable experience, and one is disposed to wonder if Homer also sat here chatting with the locals and enjoying the splendid view over the bay. The cottage that Homer subsequently moved to, and the building on the bank top where he rented a room to use as his studio, have now been demolished, but the locations are still identifiable as is the site of Dove Cottage (or Sparra Haarl) which was the original manor house of the village that Homer knew well.

Fig 92. Cullercoats Bay today
Photo: Peter R. Hornby

Fig 93. Cullercoats Bay with Tynemouth
Priory and Castle in the distance
Photo: Peter R. Hornby

A short distance to the south is Tynemouth Long Sands and King Edward's Bay with Tynemouth Priory still standing like a sentinel on its rocky prominence of Pen Bal Crag, looking out to sea and guarding the mouth of the River Tyne whose piers were, and still are, a welcome sight for sailors returning to port. The Tynemouth Volunteer Life Brigade Watch House, the first Life Brigade to be formed in England, still commands a splendid view over the entrance to the river and the infamous Black Midden Rocks where many a ship foundered in heavy seas.

Standing in Tynemouth Haven near the Watch House in inclement weather, one can see and feel how Homer must have felt when he witnessed the events of that dark and stormy day in October 1881 that inspired him to sketch and subsequently paint his great atmospheric work, "The Wreck of the Iron Crown".

Further south in North Yorkshire, Flamborough Head and Bridlington Quay where Homer found inspiration to produce such works as "A Voice from the Cliffs", "Flamborough Head", "Storm on the English Coast", "Bridlington Quay", and his magnificent oil painting, "Hark! The Lark", still attract myriads of painters, both amateur and professional, to record the breathtaking scenery and seascapes.

Today Cullercoats village attracts holidaymakers, day-trippers, and the locals who sunbathe, picnic, eat ice cream, and play games on the sandy beach, blissfully unaware of the toil and hardship endured by the fishermen and women of yesteryear.

Although the traditional workaday life of the fishing village has long since disappeared, the community spirit lives on as attested to by the hard work and effort that the villagers put into the raising of funds for the building of the community centre which was finally completed in the early 1980's and which is now a focal point for the social life of the village and its inhabitants. Many of the descendants of the original families still live in Cullercoats, and zealously guard and uphold many of the traditions that helped to establish the village as such a unique and fascinating place to live.

The traditional cries of the fishwives selling their fish have been replaced with the squeals of pleasure and delight as the young (and not so young) play their games and frolic on the sandy beach. Painters still abound in the village today. The amateurs just painting what they see for pleasure and enjoyment, and the professionals striving to find the right atmospheric conditions that will turn their work into a masterpiece. And on warm Sunday mornings, members of the Cullercoats Art Club can be found on the Bank Top displaying their work for passers-by to see and enjoy (and perhaps buy!).

A walk through the village and along the beach and over the cliffs that Homer came to know so well evoke a feeling of awe for those hard working fisherfolk whose life was dedicated to the grim realities of surviving and bringing up their families in the harsh environment that the North East Coast of England presented them with.

Whatever turned Homer's feet in the direction of Cullercoats we shall perhaps never be certain, but the friendliness of the villagers, and his fascination with their hard working lives, and the excellent subjects that they made for his brush, encouraged him to reside in Cullercoats for 18 months, and was a turning point in his career as an artist.

Fig 94. Blyth Pier, North of Cullercoats
Photo: Peter R. Hornby

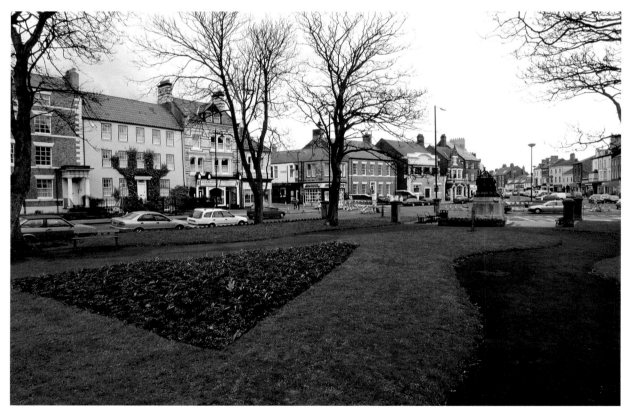

Fig 95. Tynemouth Village
Photo: Peter R. Hornby

CATALOGUE OF WINSLOW HOMER'S ENGLISH WORKS

The entries in the catalogue that follows have been arranged by location – the locations being shown on the map on page 64. Unfortunately, for various reasons, it has not been possible to reproduce a photograph of every catalogued work, but the majority are shown here.

I have spent many years tracking down works that Homer produced whilst in England and, with the help of many kind individuals and institutions, I have managed to locate 170 works... so far! The entries in the catalogue are prefixed with the letter E (for English), and have all been seen by me in one form or another. I have either seen the original, or a photograph, or a reproduction in other books or magazines. Many works were known by former or alternative names, and these are indicated in brackets next to the title by which they are presently known. Undoubtedly, there will be other works that Homer produced during his trip to England that I have failed to locate. If any reader knows of the existence of other English works, I would be pleased to have details, both for my own research, and to be added to any future edition of this book. Please contact me through the publisher, or e-mail me at: tony@winslow-homer.org

For continuity and ease of identification, I have retained the E reference numbers which I allocated in 1995 when I compiled my first catalogue of Homer's English Works. New entries since then have been placed in position by location and a suffix (a,b,c, etc.) then added to the preceeding E number to generate a catalogue reference number for the new entry. Reference numbers for any future edition of this book or subsequent revision of the catalogue will be allocated in the same way.

In addition to the catalogue in this book, I have established a website devoted to the work of Winslow Homer. The website is an on-going long-term project which contains a catalogue of all Homer's known work that he executed throughout his life, along with listings of books, articles, and videos about Homer that have been published over the years. There are also links to other websites that contain information on the artist. The listings are continuously being updated and expanded as my research continues.

You can visit the website at: http://www.winslow-homer.org

Map Showing Locations Where Winslow Homer Painted In and Around Cullercoats

Section A - On Board the S.S.Parthia

Section B - In London

Section C - Blyth, 5 miles North of Cullercoats

← Section D - Table Rocks, Whitley Bay

← Section E - Brown's Point, Cullercoats

← Section F - Cullercoats Village

← Section G - Cullercoats Bay, North of North Pier

← Section H - Cullercoats Watch House

← Section I - North Pier

← Section J - Cullercoats Bay

← Section K - Cullercoats Beacon & Saddle Rocks

← Section L - Tynemouth North Point

← Section M - Tynemouth Beach (Long Sands)

Section N - Offshore →

Section O - Tynemouth Haven

Section P - Flamborough Head & Bridlington

Section Q - Miscellaneous

Section A
On Board the S.S.Parthia

E1 "Observation on Shipboard"
(or "View Aft on the 'Parthia'
bound for Liverpool") - March 1881

Watercolour. 9¹/₄ x 11¹/₂ inches
(23.5 x 29.2 cm)
Signed lower right: Homer.

©Cooper-Hewitt National Design Museum
Smithsonian Institution, New York

Homer painted this watercolour, and E2,
during his voyage to England aboard the
Parthia, in March 1881.

E2 "Marine" - 15 March 1881

Watercolour over graphite
on off-white wove paper.
9³/₄ x 13¹/₂ inches
(24.8 x 34.3 cm)

Signed lower left: Winslow Homer 1881.
Inscribed in graphite on back:
A.F. Moulton, Class of 1873,
A.M. 1876, L.L.D. 1928

©Bowdoin College Museum of Art,
Brunswick, Maine. Bequest of the
Honourable Augustus F. Moulton.
Acc. No: 1933.001

In London

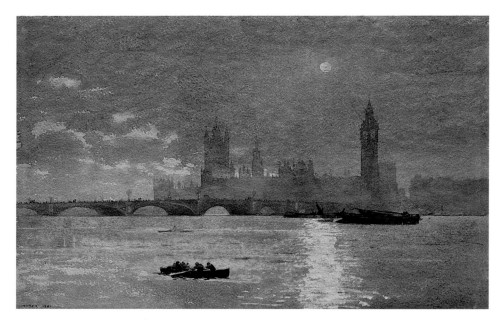

E3 "The Houses of Parliament" - 1881

Watercolour. 12 ³/₄ x 19 ³/₄ inches
(32.4 x 50.2 cm)

Signed lower left: Homer 1881.

*©Hirshhorn Museum
and Sculpture Garden,
Smithsonian Institution, Washington.
Gift of Joseph H. Hirshhorn, 1966.
Acc. No: 1966.66.2488*

This painting was the first work undertaken
by Homer after he arrived in England.
Following his disembarkation at Liverpool,
he went to London, painting this picture during
a short stay before travelling to Scarborough
and then on to Cullercoats.

Section C

Blyth Sands, North of Cullercoats

E4 "Blyth Sands" - 1882

Charcoal, graphite, ink, chalk
and opaque white on paper.
17 x 22 ⁵/₈ inches (48.2 x 57.8 cm)

Inscribed lower right:
Homer 1882.

*©Amon Carter Museum,
Fort Worth, Texas.
Acc. No: 1982.58*

Blyth is a small fishing community
a few miles north of Cullercoats.
It is quite possible that Homer visited
Blyth, although the nondescript nature
of the background does not conclusively
identify the work to Blyth.

Table Rocks, Whitley Bay, North of Cullercoats

E5 "Looking over the Cliffs" - 1882

Watercolour. 20¹/₂ x 13¹/₂ inches
(52.1 x 34.3 cm)

Signed lower left:
Winslow Homer 1882.

©*Plainfield Public Library, Plainfield, New Jersey.*

E7 "Looking over the Cliff"

Wood Engraving.

©*Strong Museum, Rochester, New York.*

(Not illustrated)

E6 "Two Girls on a Cliff" - 1883

Black and grey wash with white gouache.

21¹/₄ x 15 inches (54.5 x 38.0 cm)

©*Fogg Art Museum, Harvard University, Cambridge, Massachusetts. Bequest of Mariana G. van Rensselaer. Acc. No: 1934.0122.0000*

Evidently the same girls as in *E5*.

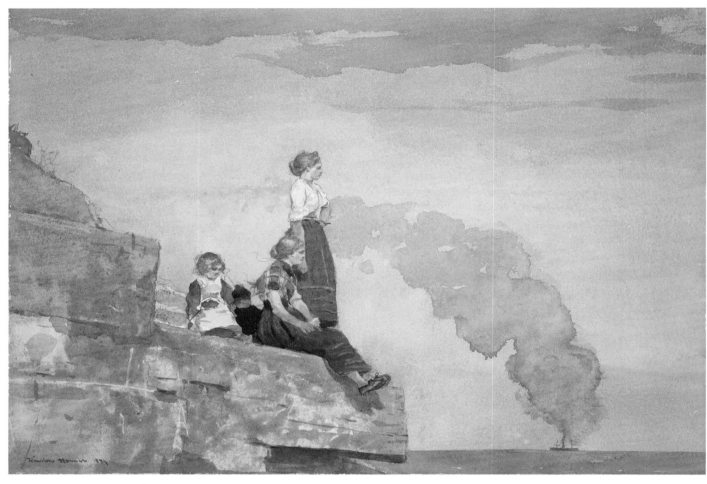

E8 "Fisherman's Family" *(or "The Lookout"*
or "The Lookout, Tynemouth, England") - 1881

Watercolour over graphite pencil on paper.
13 1/2 x 19 3/8 inches (34.2 x 49.2 cm)

Signed lower left: Winslow Homer 1881.

Section E
Cullercoats, Brown's Point

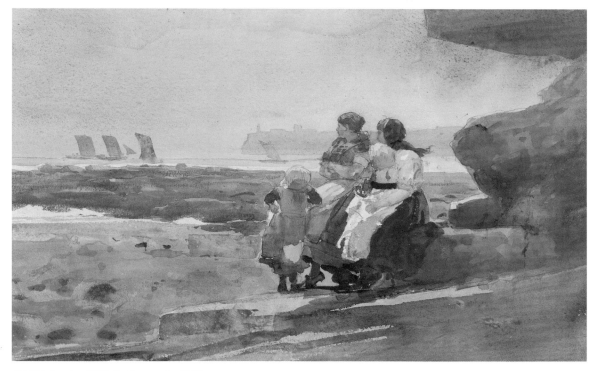

E9 "Under the Cliff, Cullercoats" - 1881

Watercolour and graphite on wove paper. 12$^{7}/_{16}$ x 19$^{7}/_{16}$ inches (31.5 x 49.4 cm)

©Addison Gallery of American Art, Phillips Academy, Andover, Massachusetts.
Gift of anonymous donor. Acc. No: 1930.386

The setting is the rocky outcrop at the north end of Cullercoats Bay. Tynemouth Priory can be seen in the distance.

Section F
Cullercoats Village

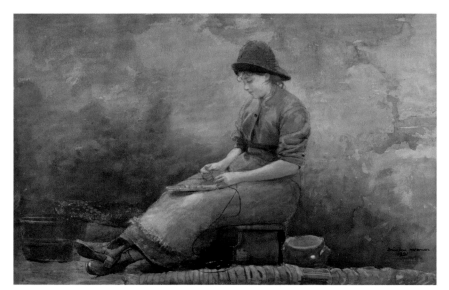

E10 "A Fishergirl Sewing" - 1881
Watercolour. 12$^{1}/_{8}$ x 18$^{1}/_{2}$ inches
(30.8 x 47.0 cm)

Signed lower right: Homer -
at a later date: Winslow Homer 1881.

©Yale University Art Gallery,
New Haven, Connecticut.
Bequest of Cristian A. Zabriskie.

This painting is actually a depiction of a fishergirl baiting lines - not sewing.

E11 "Mending the Nets"
(or "Far From Billingsgate") - 1882

Watercolour and gouache over graphite.
27³/₈ x 19¹/₄ inches (69.1x 48.9 cm)

Signed lower left: Winslow Homer 1882.

©National Gallery of Art, Washington
Bequest of Julia B. Engel.
Acc. No: 1984.58.3./DR

Fisherlasses sitting outside their houses and
mending the fishing nets were a common sight
in Cullercoats at the time of Homer's visit.

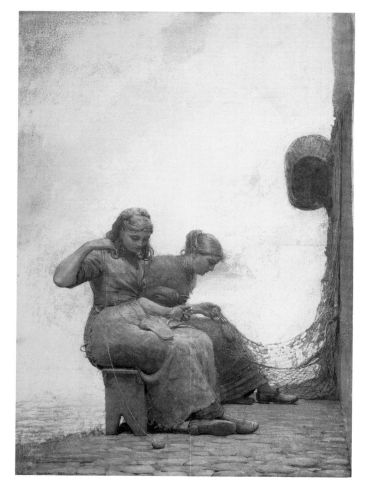

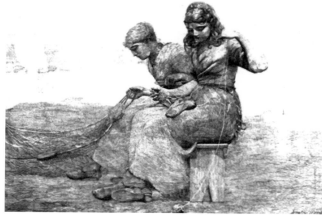

E12 "Mending the Tears" *(originally "Improve the*
Present Hour") - 1888

Etching. 17³/₈ x 23 inches (44.1 x 58.4 cm)

©Strong Museum, Rochester, New York.

This etching, adapted from E11 and made by Homer some five
years after his return to America, originally had the title
Improve the Present Hour.[1] Representations at National Gallery
of Art, Museum of Fine Arts, Boston, etc.

E13 "Sparrow Hall, Cullercoats"
(formerly known as "Fisherfolks, Tynemouth") - 1882

Oil on Canvas. 15¹/₂ x 22¹/₂ inches (39.4 x 57.2 cm)

Private Collection.

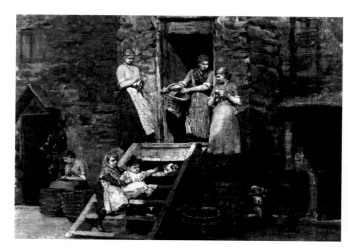

The building in the background is Dove Cottage, the first house to be built in Cullercoats. It was
built by John Dove in 1682 when he established Cullercoats as a coal-exporting harbour. The
painting depicts the south side of the building with fishwives and children outside the central
block and west wing. By the time that Homer arrived in 1881, the interior of the building had
been divided into several sections. Some of the locals called the building Sparrow Hall mistaking
the depiction of a Dove on the lintel above the entrance for a sparrow. The people depicted in the
painting are members of the Brunton and Simpson families, the ancestors of Cud Simpson, who
was one of the last residents of Dove Cottage prior to its demolition in 1979. Cud Simpson
also told me that the house had a secret room where fishermen hid from the notorious Press
Gangs. The room was behind the bricked-up window shown in the upper right of the painting.

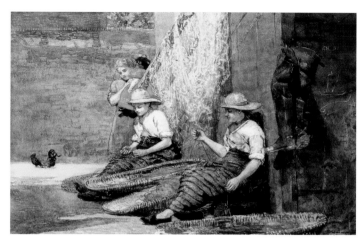

E14 "Fishergirls" - 1881

Watercolour. 17 x 23 inches (43.2 x 58.4 cm)

Signed lower right: Winslow Homer 1881

Private Collection.

The setting is outside of 44 Front Street, Cullercoats,
the cottage rented by Homer whilst in Cullercoats.
The high wall mentioned by Downes is in the background.

E14A "Picking Flowers" - 1881

Watercolour. $9^{15}/_{16}$ x $16^{1}/_{2}$ inches (25.4 x 41.9 cm)

Signed lower right: Homer 1881

Private Collection / Bridgeman Art Library.

E15 "Men and Women Looking Out to
Sea, Cullercoats, England" - 1881

Graphite on heavy wove paper.
$6^{9}/_{16}$ x $5^{9}/_{16}$ inches (16.9 x 14.2 cm)

©*Cooper-Hewitt National Design Museum,
Smithsonian Institution, New York .
Gift of Charles Savage Homer Jr.*
Acc. No: 1912.12.24 verso

E16 "Figures in Lee of Building
with Ocean Beyond,
Cullercoats, England" - 1881

Charcoal and graphite on
off-white wove paper.
$6^{3}/_{8}$ x $9^{15}/_{16}$ inches
(16.2 x 25.2 cm)

©*Cooper-Hewitt National Design Museum
Smithsonian Institution, New York.
Gift of Charles Savage Homer Jr.*
Acc. No: 1912.12.270 recto

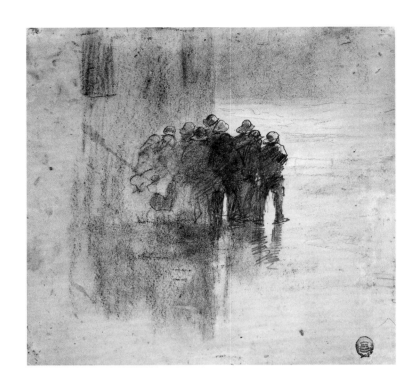

E17 "Fishermen in Oilskins,
Cullercoats, England" - 1881

Graphite, charcoal, white chalk
on heavy beige wove paper
11^{15}/$_{16}$ x 12^{5}/$_{8}$ inches (30.3 x 32.0 cm)

©Cooper-Hewitt National Design Museum,
Smithsonian Institution, New York.
Gift of Charles Savage Homer Jr.
Acc. No: 1912.12.25

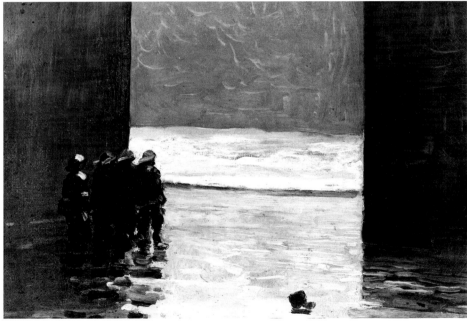

E18 "The Life Brigade" - 1881

Oil on Canvas. 12^{1}/$_{4}$ x 17^{1}/$_{4}$ inches
(31.1 x 43.8 cm)

Private Collection.

The sketches shown in *E15*, *E16*, and *E17*
were the basis for this painting.

E19 "Groups of Figures and Two Small
Framed Sketches" - 1881

Charcoal and graphite on off-white wove paper.
6^{3}/$_{8}$ x 9^{15}/$_{16}$ inches (16.2 x 25.2 cm)

©Cooper-Hewitt National Design Museum, Smithsonian
Institution, New York. Gift of Charles Savage Homer Jr.
Acc. No: 1912.12.270 verso
Photo Scott Hyde

Section G

Cullercoats Watch House

E22 "Two Women and a Child at a Rail Overlooking the Beach at Tynemouth" - 1881

Charcoal on cream wove paper.
8 x 11¾ inches (20.3 x 29.8 cm)

©Cooper-Hewitt National Design Museum, Smithsonian Institution, New York. Gift of Charles Savage Homer Jr. Acc. No: 1912.12.17

This is one of the many sketches and paintings that feature the Cullercoats Volunteer Life Brigade Watch House. The Watch House is the most prominent building in Cullercoats, and a focal point of the fisherfolks lives.

E23 "House at a Railing with Beached Dories, Cullercoats, England" - 1881

Pen and brown ink on tan laid paper.
4⅛ x 7¹/₁₆ inches (10.5 x 18.0 cm)

©Cooper-Hewitt National Design Museum, Smithsonian Institution, New York. Gift of Charles Savage Homer Jr. Acc. No: 1912.12.4

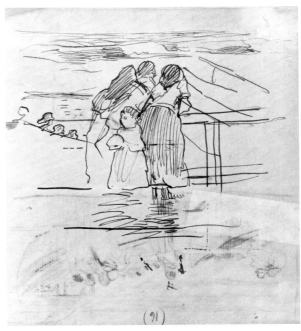

E24 "Three Women Watching the Launching of Dories, Cullercoats, England " - 1881

Pen and brown ink on off-white wove paper.
7¹³/₁₆ x 7¹/₁₆ inches (19.9 x 17.9 cm)

©Cooper-Hewitt National Design Museum Smithsonian Institution, New York. Gift of Charles Savage Homer Jr. Acc. No: 1912.12.16 recto
Photo: John Parnell

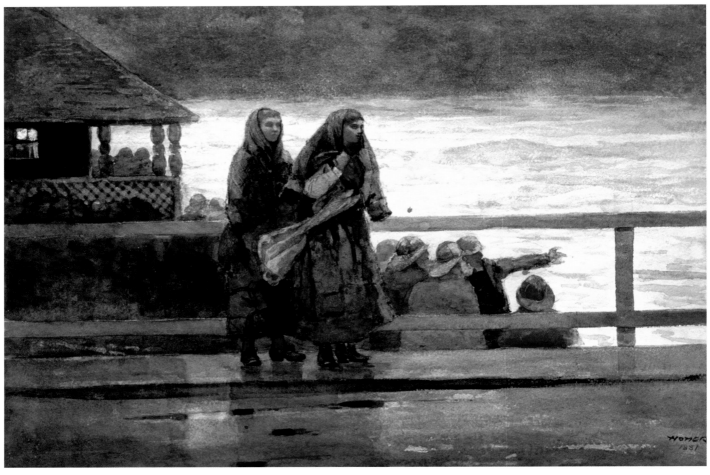

E25 "Perils of the Sea" - 1881

Watercolour over light sketch in black chalk.
14⁵/₈ x 21 inches (37.0 x 53.4 cm)

Signed lower right: Homer/1881.

©*Sterling and Francine Clark Art Institute,*
Williamstown, Massachusetts.
Acc. No: 1955.774

This is a typical cold, dark, stormy day with a heavy sea running. The women are well wrapped up against the cold, waiting for the return of the fishermen. The presence of so many fishermen and the anxious look on the women's faces, suggest that some cobles are late in returning. Many scholars consider this painting to be one of Homer's most important Cullercoats works. Helen Cooper, for instance, believes it to be the culmination of nine preparatory sketches.[2]

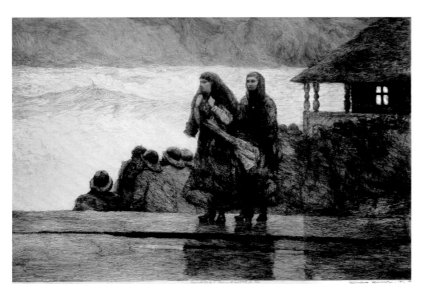

E26 "Perils of the Sea" - 1888

Etching. 16¹/₂ x 22 inches (41.9 x 55.9 cm)

©*McNay Art Museum, San Antonio, Texas.*
Gift of the Friends of the McNay

This etching was produced by Homer in 1888 from his watercolour of the same title *(E25).*[3]

Representations also at Museum of Fine Arts Boston, Metropolitan Museum of Art, National Museum of American Art, Strong Museum, etc.

E27 "The Last Boat In" - c. 1881

Charcoal and chalk on wove paper
mounted on board.
8 7/16 x 12 3/16 inches (21.4 x 31.0 cm)

Signed lower left: Homer.

©*Addison Gallery of American Art,*
Phillips Academy, Andover,
Massachusetts.
Acc. No: 1934.39

Anxious fishermen await the return
of fishing cobles during a stormy day.
The boat in the sea could possibly be
the Cullercoats Lifeboat on its way to
assist a coble in difficulties.

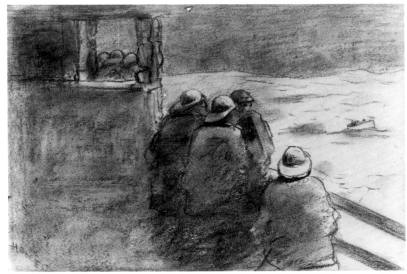

E28 "A Dark Hour, Tynemouth"
1882

Charcoal. 8 1/4 x 12 inches
(21.0 x 30.5 cm)
Signed lower left: H.

©*Sheldon Memorial Art Gallery,*
University of Nebraska,
Lincoln, Nebraska.

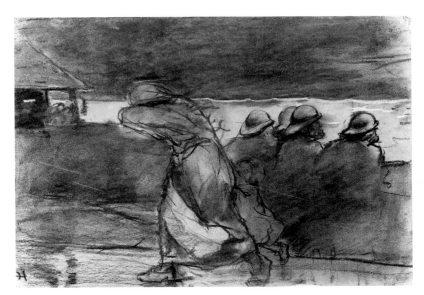

E29 "Figures Overlooking Bay and Small Boat" - 1881-82

Charcoal on Heavy off-white paper.
4 1/2 x 11 3/16 inches (11.5 x 28.4 cm)

©*Cooper-Hewitt National Design Museum,*
Smithsonian Institution, New York. Gift of Charles Savage Homer Jr.
Acc. No: 1912.12.27

E29A "Watching A Storm on the English Coast"

Oil on Canvas.

Private Collection.

(Not illustrated)

E30 "The Coming Away of the Gale" (Original Version)

Photograph. 4⁷/₈ x 8¹¹/₁₆ inches (12.2 x 22.7 cm)

©Bowdoin College Museum of Art, Brunswick, Maine.
Gift of the Homer family
Acc. No: 1964.069.176.001

When first exhibited in 1883, this painting was rejected by the critics and subsequently disappeared from view. It was thought to be lost until a painting showing the same fishergirl was exhibited ten years later in 1893. This painting was entitled *The Gale*, and subsequent X-radiographs confirmed that Homer had repainted the background and re-named the work. This photograph is signed by Homer, but it is not clear whether or not he actually took the photograph himself.

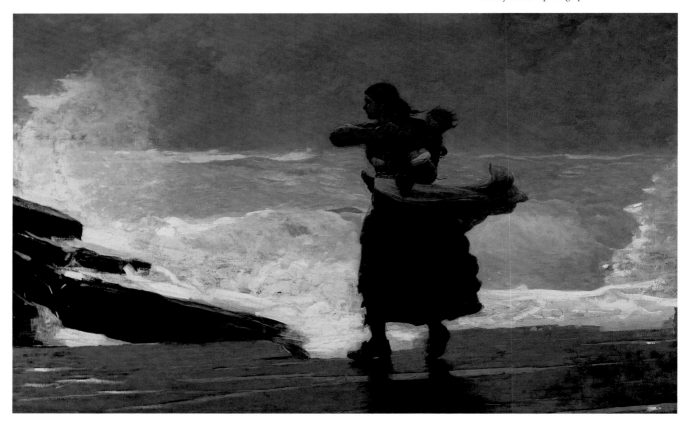

E31 "The Gale" - 1883-93

Oil on Canvas.
30¹/₄ x 48⁵/₁₆ inches (74.9 x 121.9 cm)

Signed lower right: Winslow Homer 1893.

©Worcester Art Museum, Worcester, Massachusetts.

The original version of this painting *(E30)*, included part of the Cullercoats Watch House, but Homer painted out the Watch House and added a stormy sea, exhibiting this version for the first time in 1893. The painting sold for a record $30,000 in 1916, six years after Homer's death.

E32 "Women Watching the Launching of Dories" - 1881

Pen and brown ink on off-white wove paper
7 13/16 x 7 1/16 inches (19.9 x 17.9 cm)

©Cooper-Hewitt National Design Museum,
Smithsonian Institution, New York.
Gift of Charles Savage Homer Jr.
Acc. No: 1912.12.16 verso lower
Photo: John Parnell

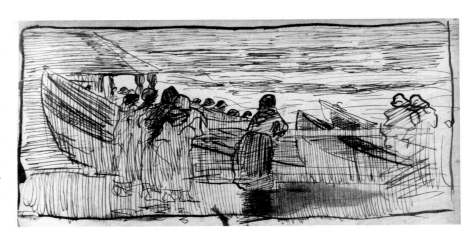

E33 "Figures Watching the
Landing of Dories" - 1881

Pen and brown ink on off-white wove paper.
7 13/16 x 7 1/16 inches (19.9 x 17.9 cm)

©Cooper-Hewitt National Design Museum
Smithsonian Institution, New York.
Gift of Charles Savage Homer Jr.
Acc No: 1912.12.16 verso upper
Photo: John Parnell

E34 "Fisherwoman by Rail,
Cullercoats, England" - 1881-2

Graphite on gray-green wove paper.
6 9/16 x 8 7/16 inches (16.7 x 21.5 cm).

©Cooper-Hewitt National Design Museum,
Smithsonian Institution, New York.
Gift of Charles Savage Homer Jr.
Acc. No: 1912.12.30 Lower Left

Cullercoats Bay, East of North Pier

E35 "Study for Inside The Bar, Tynemouth"

Watercolour and graphite on paper.

©*McNay Art Museum, San Antonio, Texas. Bequest of Mrs. Jerry Lawson.*

From this study Homer developed *Windy Day, Cullercoats* (*E36*) adding the fisherlass. Later, at his studio in Prout's Neck, in 1883, he then produced his dramatic watercolour *Inside The Bar, Cullercoats* (*E37*).

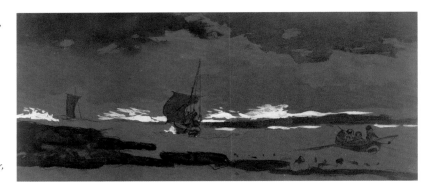

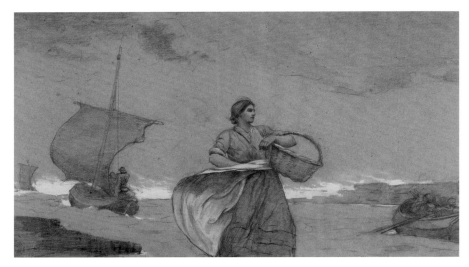

E36 "Windy Day, Cullercoats" - 1881

Graphite and gouache on paper.
11³/₁₆ x 20¼ inches (28.4 x 51.4 cm)

Signed lower left: Winslow Homer 1881.

©*Portland Museum of Art, Portland, Maine. Bequest of Charles Shipman Payson. Acc. No: 1988.55.17*

Photo: Melville McLean.

E37 "Inside The Bar, Cullercoats" - 1883
Watercolour. 15³/₈ x 28½ inches
(39.1 x 72.4 cm)
Signed lower right: Homer '83.

©*Metropolitan Museum of Art, New York. Gift of Louise Ryals Arkell, in memory of her husband, Bartlett Arkell. Acc. No: 54.183*

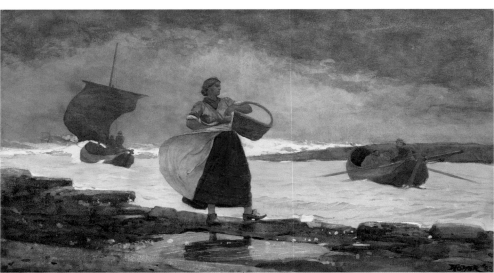

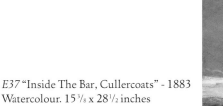

This watercolour was produced in America in 1883 after Homer had returned from England. A number of other works with Cullercoats subjects were also produced by Homer after his return to America, indicating the deep affection that he retained for the village and the fisherfolk.

E38 "After the Storm" - 1882

Charcoal with touches of white on tan wove paper.
11¹/₂ x 8⁷/₁₆ inches (29.4 x 21.5 cm)

Signed lower right: H.

©*Princeton University Art Museum, New Jersey.*
Gift of Frank Jewett Mather Jr.
Acc. No: 1949.149

This drawing is a study for "Girl with Red Stockings" *(E39).*

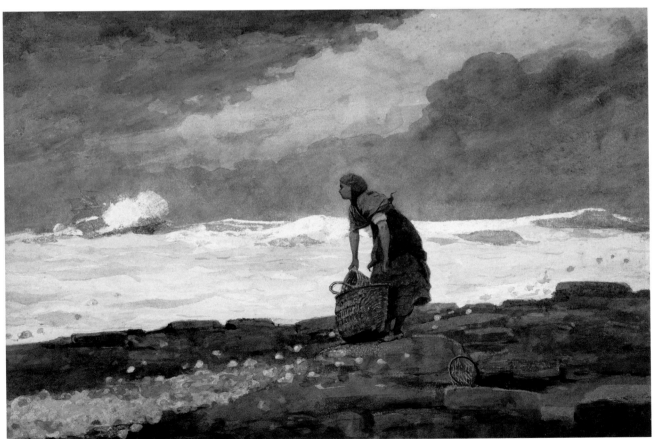

E39 "Girl with Red Stockings" *(or "The Wreck" or "Fishergirl")* - 1882

Watercolour with graphite pencil on paper.
13⁷/₁₆ x 19¹/₂ inches (34.2 x 49.5 cm)

Signed lower right: Homer/1882. Reverse: Girl with Red Stockings.

©*2003 Museum of Fine Arts, Boston, Massachusetts.*
Bequest of John T. Spaulding. Acc. No: 48.727

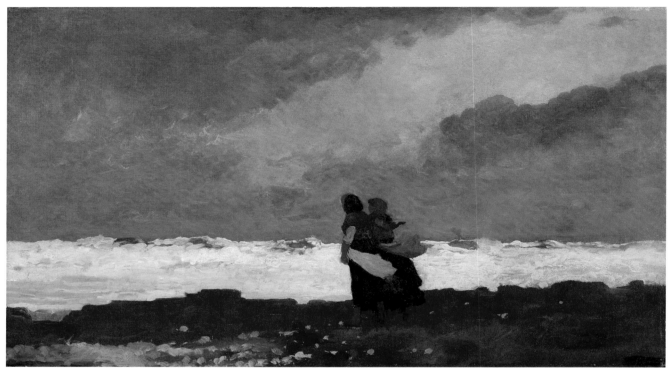

E40 "Two Figures by the Sea" *(or "The Storm")* - 1882

Oil on Canvas. 19 ³/₄ x 35 inches (50.2 x 88.9 cm)

©Denver Art Museum, Denver, Colorado.
Helen Dill Collection. Acc. No: 1935.8

E41 "Fisherwomen, Tynemouth"

Drawing.

Collection Unknown.

E42 "Danger" - 1883-87

Watercolour and
gouache over graphite.
14³/₄ x 21¹/₁₆ inches
(37.5 x 53.5 cm)

Signed lower right:
Winslow Homer 1883,
and above:
Winslow Homer 87.

©*National Gallery of Art,
Washington.
Bequest of Julia B. Engel.
Acc. No: 1984.58.2./DR*

E43 "Women on Rocky Shore" - 1881-82

Charcoal with white gouache
on wove paper.
7⁵/₈ x 12⁵/₈ inches (19.3 x 31.9 cm)

Signed lower right: Homer.

©*Princeton University Art Museum,
Princeton, New Jersey.
Gift of Frank Jewett Mather Jr.
Acc. No: 1943.25*

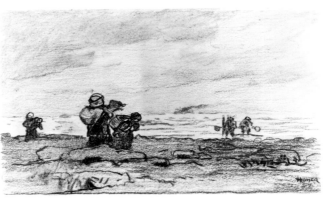

E44 "Waiting for the Return
of the Fishing Fleets" *("A Fisherman's Family")* - 1881

Watercolour.

Private Collection.

This painting was undertaken for William Cochrane,
and hung on the wall of Oakfield House, Gosforth,
Newcastle upon Tyne, until the death of
William Cochrane's nephew
Sir Cecil Cochrane in 1960.

(Not Illustrated)

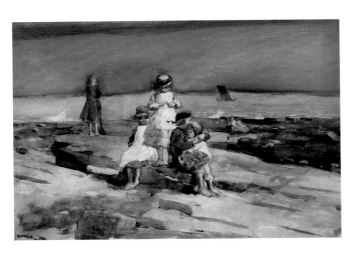

E44A "Children on the Beach" - 1881

Watercolour. 13 x 18 7/8 inches (33.0 x 48.0 cm)

Signed lower left: Homer 1881.

Private Collection

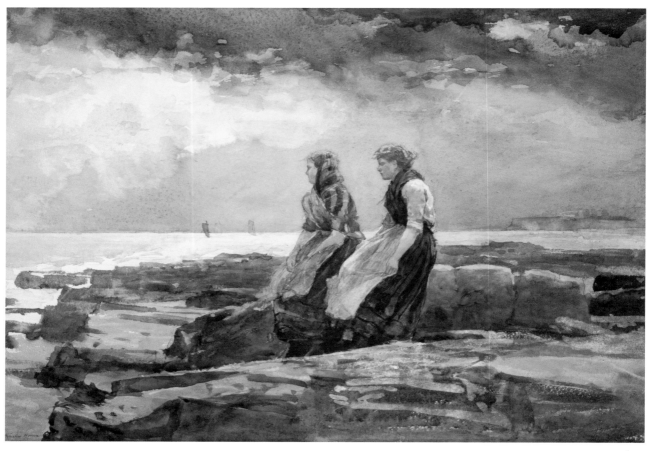

E45 "Looking out to Sea" - 1881

Watercolour. 13$\frac{1}{4}$ x 19 inches (33.6 x48.2 cm)

Signed lower left: Winslow Homer.

©Fogg Art Museum, Harvard University,
Cambridge, Massachusetts. Anonymous gift.
Acc. No: 1939.0232.0000

E46 "Sun and Clouds" - 1882

Watercolour. 12$\frac{1}{2}$ x 21$\frac{1}{2}$ inches (31.8 x 54.6 cm)

Signed lower left: Homer. Reverse: No 5.

©Freer Gallery of Art, Smithsonian Institution,
Washington, D.C. Gift of Charles Lang Freer.
Acc. No: F1913.31

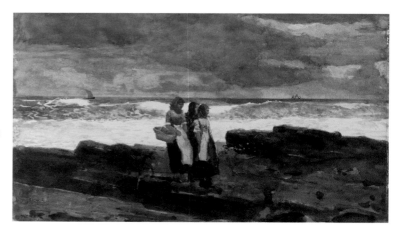

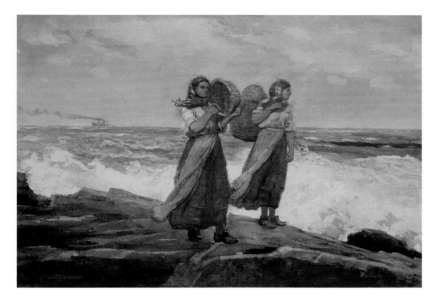

E46A "A Fresh Breeze"
(or "Fishergirls, England") - 1881

Transparent and opaque watercolour
over graphite pencil on paper.
14 x 20 inches (35.6 x 50.8 cm)

©2003 Museum of Fine Arts
Boston, Massachusetts.
Gift in memory of Ward and Louisa
Hooper Thoron from their son.
Acc. No: 1998.581

E47 "Fishwives" - 1883

Watercolour on paper. 18 x 29½ inches
(45.7 x 74.9 cm)

Signed lower right: Homer 1883.

©Currier Gallery of Art
Manchester, New Hampshire.
Museum purchase. Acc. No: 1938.1

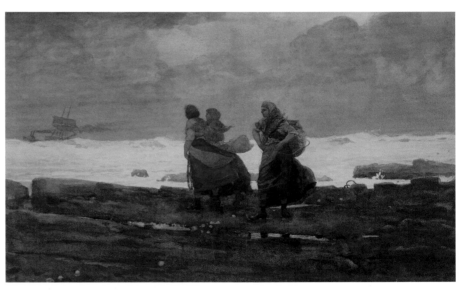

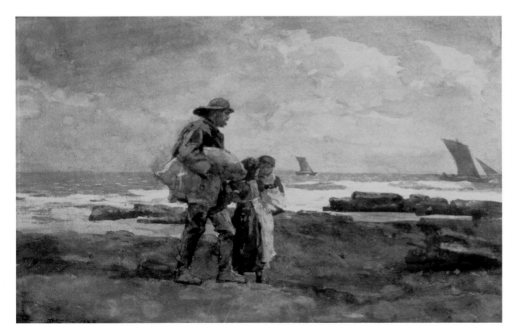

E48 "Homecoming" - 1883

Watercolour.
14½ x 21½ inches (36.8 x 54.6 cm)

Signed lower left: Winslow Homer
1883.

©Canajoharie Library and Art Gallery
Canajoharie, New York.

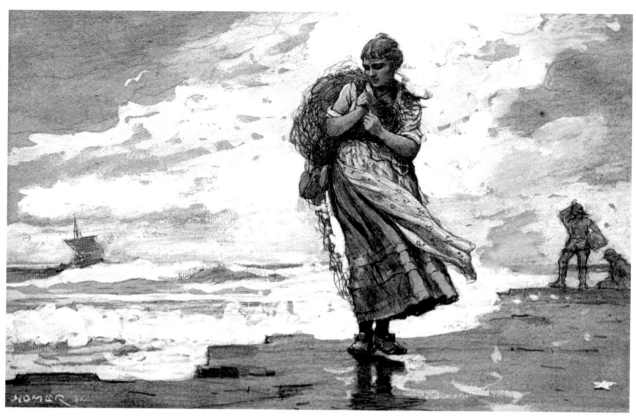

E49 "Fishergirl with Net" - 1882

Pencil with white gouache and wash.
11³/₈ x 16¹/₈ inches (28.9 x 41.0 cm)

Signed lower left: Homer.

©Sterling and Francine Clark Art Institute,
Williamstown, Massachusetts.
Acc. No: 1955.1485

E50 "Figures on Coast" - 1882

Charcoal. 6³/₄ x 12¹/₄ inches
(17.0 x 31.1 cm)

Signed lower left: Homer 82.

©Carnegie Museum of Art,
Pittsburgh, Pennsylvania.

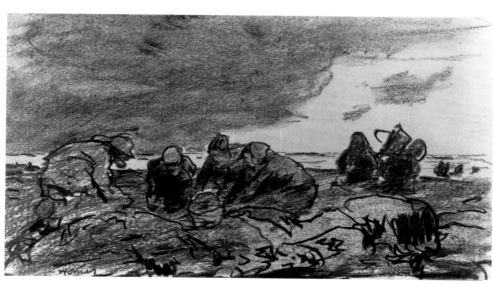

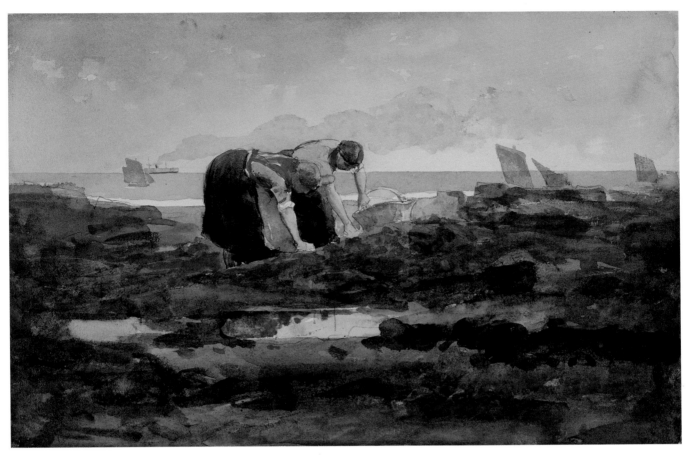

E51 "The Mussel Gatherers" - c. 1881-82

Watercolour over graphite.
14½ x 21¼ inches (37.0 x 54.9 cm)

©*The Baltimore Museum of Art,
Baltimore, Maryland.
Gift of Alvin and Fannie B. Thalheimer.
Acc. No: BMA 1956.226*

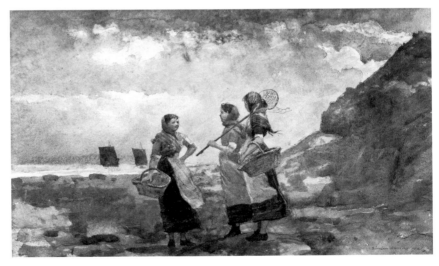

E52 "Three Fishergirls, Tynemouth" - 1881

Watercolour.
11½ x 19 inches (29.2 x 48.2 cm)

*Collection of Mr. & Mrs. Paul Mellon,
Upperville, Virginia.*

E51A "Starfish" - 1881-82

Ink wash, gouache and pencil.
7⅞ x 7⅞ inches (20.0 x 20.0 cm)

Signed lower right: Homer

Collection unknown.

(Not Illustrated)

E53 "Women on the Sands"
(or "Mussel Gatherers") - 1881-82

Black and white watercolour
with white chalk on brown paper.
8⁵/₈ x 13 inches (21.9 x 33.0 cm)

Signed lower left: Homer.

©2003 Museum of Fine Arts, Boston, Massachusetts.
*Gift of the Estate of Mrs. Sarah Wyman Whitman,
through Mrs. Henry Parkman.
Acc. No: 09.213*

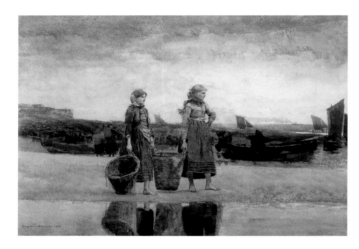

E54 "Two Girls at the Beach,
Tynemouth" - 1881

Watercolour. 13⁷/₈ x 19³/₄ inches
(35.1 x 50.2 cm)

Private Collection.

E55 "Women Looking Out to Sea"

Charcoal.
8 x 12 inches (20.3 x 30.5 cm)

Signed lower left: W. Homer.

Private Collection.

(Not Illustrated)

E55A "On the Mussel Bed"

Watercolour with Chalk.
9 ⁷/₈ x 18 ¹/₈ inches (25 x 46 cm)

Signed lower left: Homer 1881

Collection unknown.

(Not Illustrated)

Cullercoats Bay, North Pier

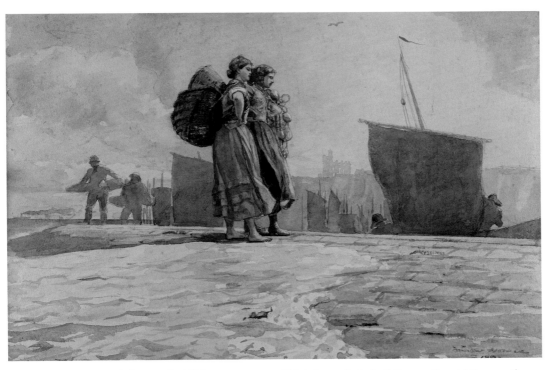

E56 "The Breakwater, Cullercoats" - 1882

Watercolour on paper.
13¹/₄ x 19³/₄ inches (33.6 x 50.2 cm)

Signed lower right: Winslow Homer 1882.

©Portland Museum of Art, Portland, Maine.
Bequest of Charles Shipman Payson.
Acc. No: 1988.55.16
Photo: Melville McLean

This is the north pier in Cullercoats Bay with Tynemouth Priory visible on the "Pen Bal Crag" prominence in the distance. In fact Tynemouth Priory is not visible from the low vantage point of the North Pier. It can be seen clearly from higher ground in Cullercoats.

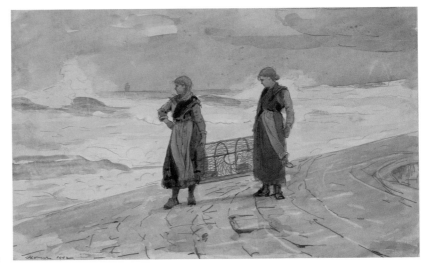

E57 "Women on Shore with Lobster Pot" - 1882

Transparent watercolour, graphite, and opaque watercolour.
7³/₄ x 12³/₁₆ inches (19.7 x 31.0 cm)

Signed lower left: Homer 1882.

©Brooklyn Museum of Art, Brooklyn, New York.
Frederick Loeser Fund.
Acc. No: 28.213

This is the north pier in Cullercoats Bay.

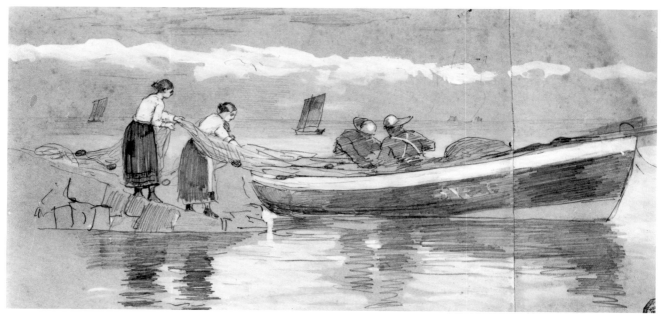

E58 "Fishermen and Women Stowing Nets in a Beached Dory, Cullercoats, England" - 1881

Graphite, brush and white gouache on two pieces of tan wove paper, joined and overlapping. 6^{15}/$_{16}$ x 14^{1}/$_{8}$ inches (17.6 x 35.8 cm)

©Cooper-Hewitt National Design Museum, Smithsonian Institution, New York. Gift of Charles Savage Homer Jr. Acc. No: 1912.12.20 a,b

The seaward end of the North Pier in Cullercoats. The title of this, and several other works refer to a Dory or Dories, when of course, the fishing boats in Cullercoats are known as Cobles.

E58A "The Breakwater" - 1883

Watercolour and pencil. 14^{1}/$_{4}$ x 21^{1}/$_{2}$ inches (36.8 x 54.1 cm) Signed lower right: Winslow Homer 1883

Collection unknown.

(Not Illustrated)

E58B "Untitled" *("On the Seawall at Cullercoats")* - 1882

Graphite and gouache on paper. 8 x 13 inches (20.3 x 33.0 cm)

©Portland museum of Art, Portland, Maine. William M.B. Berger Charitable Trust. Acc. No: 11.1996.7 Photo: Melville McLean.

Section J

Cullercoats Beach

E59 "Beach Scene, Tynemouth" - 1881

Watercolour. 5³/₄ x 4³/₄ inches (14.6 x 12.1 cm)

Collection unknown.

(Not Illustrated)

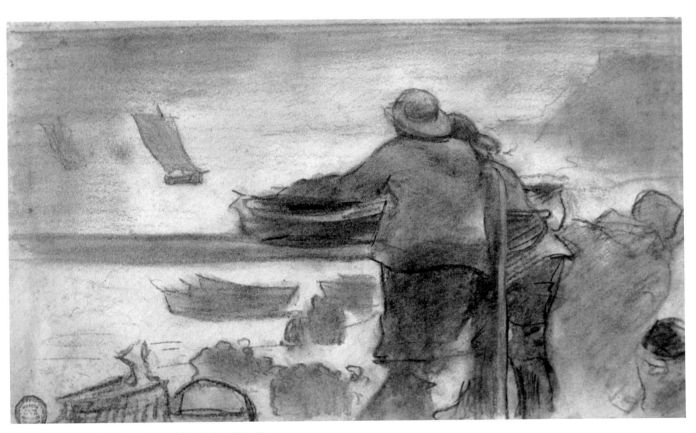

E60 "Beach with Boats and People" - 1881-82

Charcoal and white crayon on cream wove paper.
7¹/₂ x 12¹/₈ inches (19.1 x 30.8 cm)

©Cooper-Hewitt National Design Museum,
Smithsonian Institution, New York.
Gift of Charles Savage Homer Jr.
Acc. No: 1912.12.23

E61 "Beach Scene" - 1881-82

Crayon (brush and watercolour
lower left) on off-white wove paper.
8 7/16 x 12 3/16 inches. (21.5 x 30.9 cm)

©Cooper-Hewitt National Design Museum,
Smithsonian Institution, New York.
Gift of Charles Savage Homer Jr.
Acc. No: 1912.12.216

E62 "Beach Scene with
Women Carrying Baskets,
Cullercoats, England" - 1881-82

Graphite on gray-green wove paper.
6 9/16 x 8 7/16 inches (16.7 x 21.5 cm)

©Cooper-Hewitt National Design Museum,
Smithsonian Institution, New York.
Gift of Charles Savage Homer Jr.
1912-12-30 top

E63 "Beach at Low Tide,
Cullercoats, England" - 1881

Charcoal on heavy cream wove paper.
7 3/4 x 10 11/16 inches (19.7 x 27.2 cm)

©Cooper-Hewitt National Design Museum,
Smithsonian Institution, New York.
Gift of Charles Savage Homer Jr.
Acc. No: 1912.12.39
Photo: John Parnell

90

E64 "Two Boats on Beach with
Figures" - 1881-82

Graphite on off-white wove paper.
3⁹/₁₆ x 5¹/₂ inches (9.0 x 14.0 cm)

*©Cooper-Hewitt National
Design Museum, Smithsonian
Institution, New York.
Gift of Charles Savage Homer Jr
Acc. No: 1912.12.18*

E65 "Two Fishing Boats with Sails" - 1881-82

Charcoal on cream wove paper.
8³/₁₆ x 12¹/₁₆ inches (20.8 x 30.6)

*©Cooper-Hewitt National Design Museum
Smithsonian Institution, New York.
Gift of Charles Savage Homer Jr.
Acc. No: 1912.12.22*

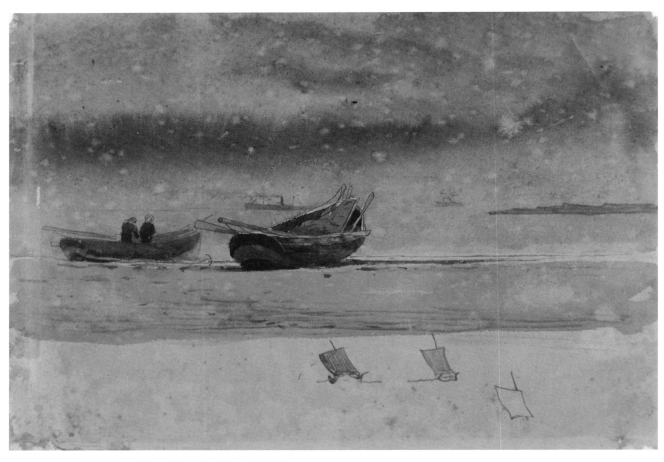

E66 "Stern View of Two Rowboats" - 1881

Graphite, brush, and watercolour on gray-green wove paper.
$9^{13}/_{16}$ x $15^{15}/_{16}$ inches (25.0 x 35.4 cm)

©Cooper-Hewitt National Design Museum,
Smithsonian Institution, New York.
Gift of Charles Savage Homer Jr.
Acc. No: 1912.12.224

E67 "Portion of a Fishing Dory" - 1881-82

Graphite on tan wove paper.
7 x $7^{3}/_{16}$ inches (17.8 x 18.2 cm)

©Cooper-Hewitt National Design Museum,
Smithsonian Institution, New York.
Gift of Charles Savage Homer Jr.
Acc. No: 1912.12.218

E68 "Sketches of Dories on Carriages" - 1881

Graphite on tan paper envelope.
$5^{7}/_{16}$ x $8^{7}/_{16}$ inches (13.8 x 21.4 cm)

©Cooper-Hewitt National Design Museum,
Smithsonian Institution, New York.
Gift of Charles Savage Homer Jr.
Acc. No: 1912.12.240

E69 "Beach Scene with
People and Fishing Boats,
Cullercoats, England" - 1881-82

Charcoal on cream wove paper.
6 x 11³/₄ inches (15.3 x 29.9 cm)

©Cooper-Hewitt National Design Museum, Smithsonian Institution, New York.
Gift of Charles Savage Homer Jr. Acc. No: 1912.12.26

E70 "Fishing Cobles, Cullercoats, England" - 1881-82

Graphite on gray-green wove paper.
6⁹/₁₆ x 8⁷/₁₆ inches (16.37 x 21.5 cm)

©Cooper-Hewitt National Design Museum,
Smithsonian Institution, New York.
Gift of Charles Savage Homer Jr.
Acc. No: 1912.12.30

E71 "Two Dories being Launched" - 1881

Pen and brown ink on cream paper.
4³/₈ x 7¹/₈ inches (11.1 x 18.1 cm)

©Cooper-Hewitt National Design Museum,
Smithsonian Institution, New York.
Gift of Charles Savage Homer Jr.
Acc. No: 1912.12.219

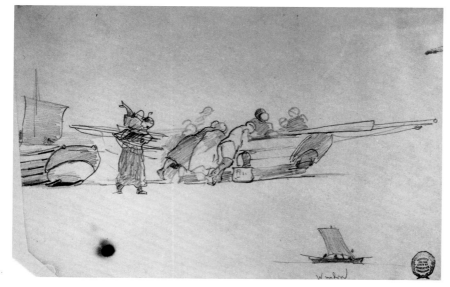

E72 "Men and Women Unloading a Dory" - 1881-8

Graphite on tan wove paper.
6¹¹/₁₆ x 10³/₁₆ inches (17 x 25.8 cm)

©*Cooper-Hewitt National Design Museum,*
Smithsonian Institution, New York.
Gift of Charles Savage Homer Jr.
Acc. No: 1912.12.19

E73 "Fisherman Clambering over
Gunwales, Cullercoats, England" - 1881-82

Charcoal on heavy cream wove paper.
8¹/₄ x 12¹⁵/₁₆ inches (21.0 x 31.3 cm)

©*Cooper-Hewitt National Design Museum,*
Smithsonian Institution, New York.
Gift of Charles Savage Homer Jr.
Acc. No: 1912.12.21

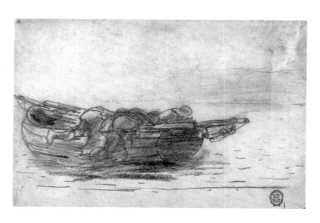

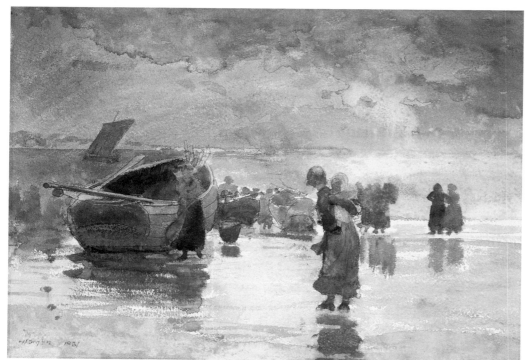

E74 "On the Sands" - 1881

Watercolour and gouache with pen
and black ink over graphite.
13³/₁₆ x 18¹¹/₁₆ inches
(35.5 x 47.5 cm)

©*National Gallery of Art, Washington.*
Bequest of Julia B. Engel.
Acc. No: 1984.58.1/DR

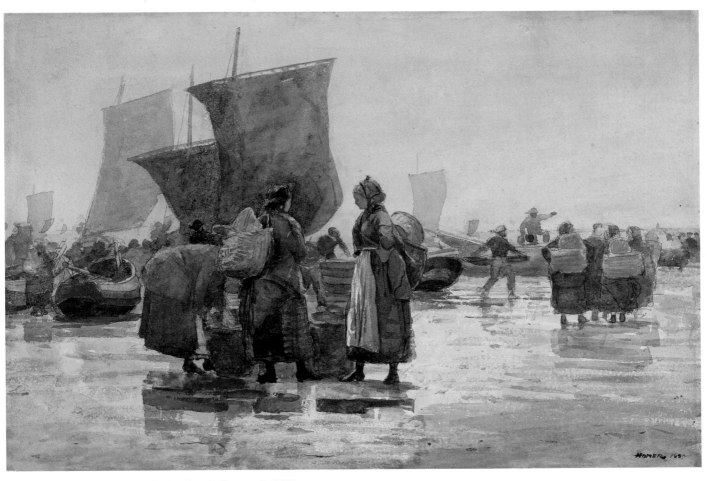

E75 "Fisherfolk on the Beach at Cullercoats" - 1881

Watercolour and graphite on wove paper.
13⁷/₁₆ x 19⁷/₁₆ inches (34.1 x 49.4 cm)

Signed lower right: Homer 1881.

©Addison Gallery of American Art,
Phillips Academy, Andover,
Massachusetts.
Gift of anonymous donor.
Acc. No: 1928.23

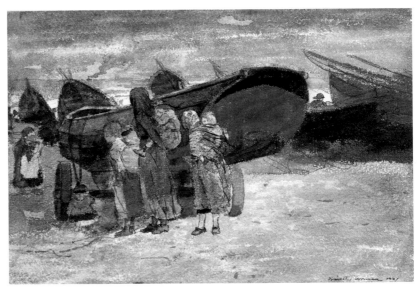

E76 "Coast Scene with Boats
on the Beach" - 1881

Watercolour over graphite
pencil on paper.
9¹/₈ x 14 inches (23.2 x 35.6 cm)

Signed lower right:
Winslow Homer 1881.

©2003 Museum of Fine Arts,
Boston, Massachusetts.
Bequest of John T. Spaulding.
Acc. No: 48.725

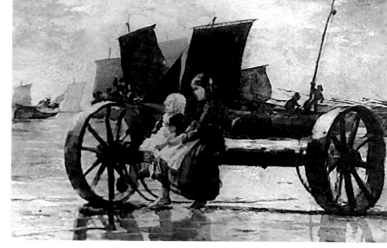

E77 "On the Beach, Cullercoats"

Watercolour and graphite.
12⅝ x 18⅞ inches (32.1 x 72.4 cm)

Collection Unknown.

E78 "The Return, Tynemouth" - 1881

Watercolour with white gouache
over graphite on off-white paper.
13½ x 13½ inches (34.4 x 34.4 cm)

Signed lower right: Homer / 1881.
Reverse: Sketch for "Hark! The Lark" (*E141*) q.v.

©Art Institute of Chicago, Chicago, Illinois.
Mr. and Mrs. Martin A. Ryerson Collection.
Acc. No: 1933.1251 recto

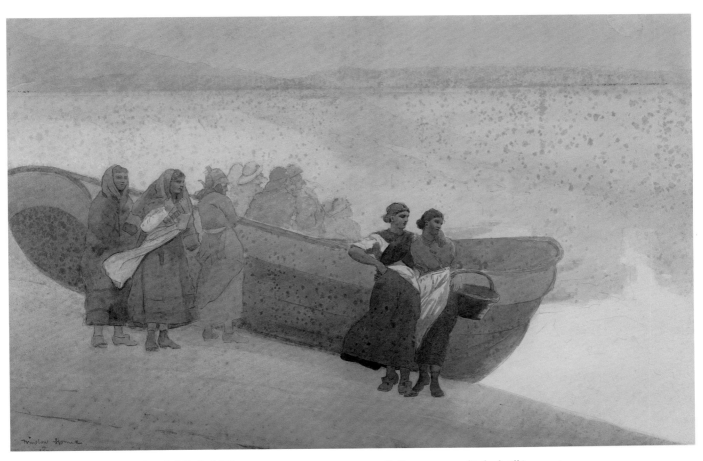

E79 "Scotch Mist" - 1883

Watercolour and graphite on paper.
15¹/₂ x 29¹/₈ inches (39.4 x 73.8 cm)

Signed lower left: Winslow Homer 1883.

©*McNay Art Museum, San Antonio, Texas.*
Bequest of Marion Koogler McNay.

Cullercoats was, and indeed still is, prone to heavy mists drifting in from the sea. They are known locally as a "Sea Fret" these days, but a century ago it was often referred to as "Scotch Mist." The mists are most common in early summer when the warm sun heats up the cold North Sea, causing it to vaporise and form a swirling mist which drifts inland.

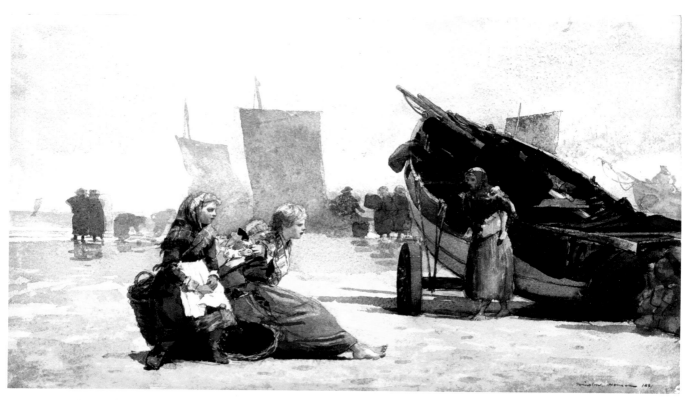

E80 "Beach Scene, Cullercoats" - 1881

Watercolour and pencil on paper.
11¹/₂ x 19¹/₂ inches
(29.2 x 49.5 cm)

Signed lower right: Winslow Homer 1881.

©*Sterling and Francine Clark Art Institute*
Williamstown, Massachusetts.
Acc. No: 1955.1490

E81 "Arrival of the Fishing Boats" - 1881

Watercolour. 13¹/₂ x 19³/₈ inches
(34.3 x 49.2 cm)

Signed lower left: Homer 1881.

©*Cincinnati Art Museum, Cincinnati, Ohio.*
Bequest of Mary Hanna. Acc. No: 1956.96

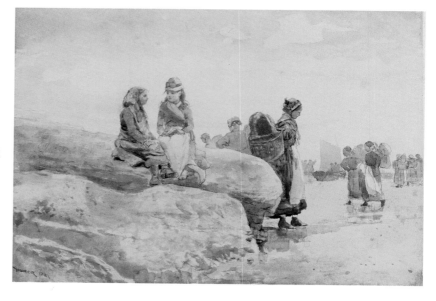

E82 "Fishermen Beaching a Dory,
Cullercoats, England" - 1881

Charcoal, black and white chalk
on heavy cream wove paper.
6¹⁵/₁₆ x 11¹³/₁₆ inches (17.6 x 30.0 cm)

*©Cooper-Hewitt National Design Museum,
Smithsonian Institution, New York.
Gift of Charles Savage Homer Jr.
Acc. No: 1912.12.41*

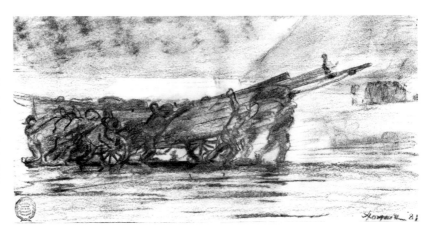

E83 "Fishermen Beaching a Boat,
Cullercoats, England" - 1881

Charcoal, brush, and white gouache
on cream wove paper.
6⁷/₁₆ x 12³/₁₆ inches (16.3 x 30.9 cm)

*©Cooper-Hewitt National Design Museum
Smithsonian Institution, New York.
Gift of Charles Savage Homer Jr.
Acc. No: 1912.12.40*

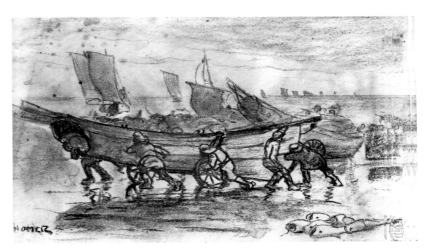

E84 "Men Beaching a Boat" - 1882

Black chalk with wash.
7¹/₂ x 12¹/₂ inches (18.4 x 31.7cm)

Signed lower right: W. H.

*©Fogg Art Museum, Harvard University
Cambridge, Massachusetts
Gift of Edward W. Forbes.
Acc. No: 1953.0202.0000*

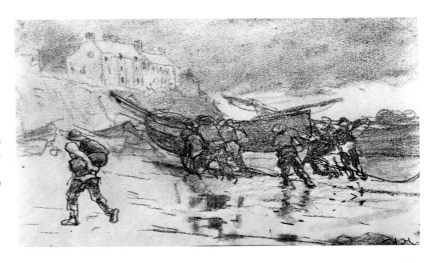

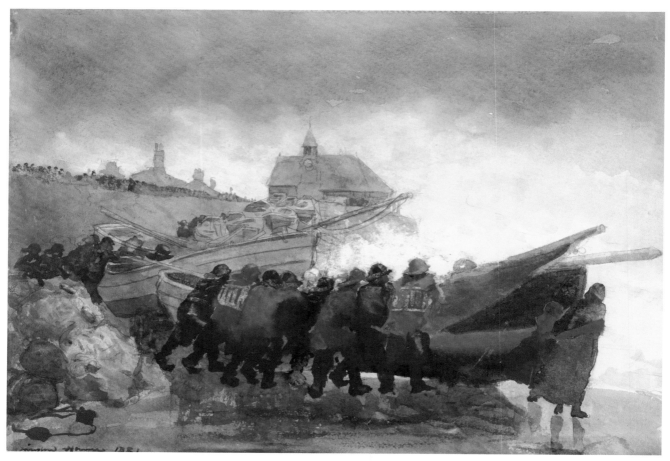

E85 "Watching the Tempest" - 1881

Watercolour. $13^7/_8$ x $18^3/_4$ inches (35.3 x 47.6 cm)

Signed lower left: Winslow Homer 1881.

©*Fogg Art Museum, Harvard University, Cambridge, Massachusetts. Bequest of Grenville L. Winthrop.*

E86 "Sketch and Notation for Four Fishwives" - 1881

Graphite. $3^5/_8$ x $5^1/_2$ inches (8.6 x 14 cm)

Formerly Collection of Lois Homer Graham.

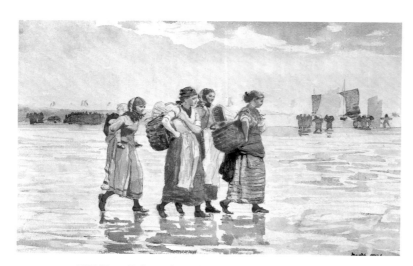

E87 "Four Fishergirls on the Beach at Tynemouth" - 1881

Watercolour. $11^1/_2$ x $18^3/_4$ inches (29.2 x 47.6 cm)
Signed lower right: W.H. 1881

Collection of Mr. and Mrs. Paul Mellon, Upperville, Virginia.

E88 "Four Fishwives" - 1881

Watercolour. 18 x 28¹/₂ inches
(45.7 x 72.4 cm)

Signed lower right:
Winslow Homer 1881.

©Scripps College,
Claremont, California
Gift of General and
Mrs. Edward Clinton Young.

Evidently the same group of Fishwives
as in *Four Fishergirls On The Beach*
At Tynemouth (E87).

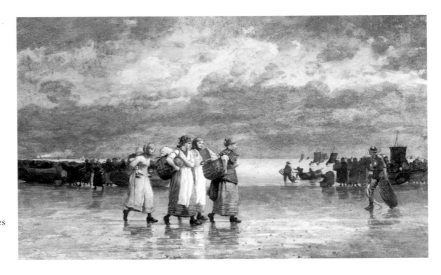

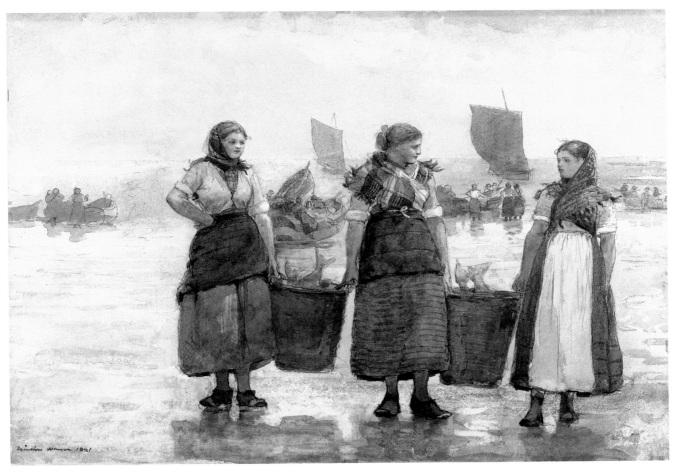

E89 "Fisherwomen, Cullercoats" - 1881

Watercolour. 13¹/₂ x 19³/₈ inches
(34.3 x 49.2 cm)

Signed lower left: Winslow Homer 1881

©Honolulu Academy of Arts, Honolulu, Hawaii
Acc. No: HAA 15.091

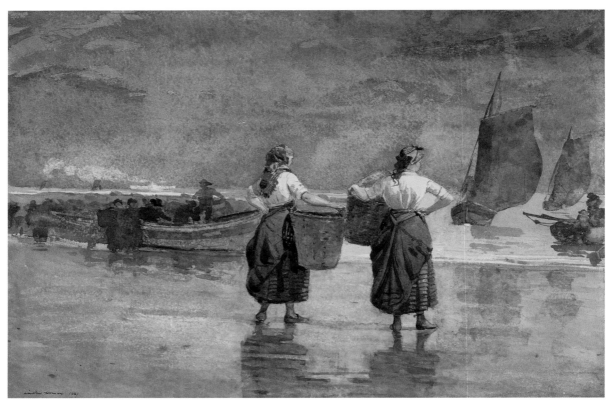

E90 "Fisher Girls on the Beach, Tynemouth"
(or "Return of the Fishing Fleet") - 1881

Watercolour. 13¹/₈ x 19³/₈ inches
(33.4 x 49.3 cm)

Signed lower left: Winslow Homer 1881.

©*Brooklyn Museum of Art, Brooklyn, New York.*
Museum Collection Fund.
Acc. No: 41.219

This is possibly the painting, simply
entitled *Cullercoats*, that Homer exhibited
at the 1881 exhibition of the Newcastle
upon Tyne Arts Association.

E90A "Looking Out to Sea"
1881-82

Watercolour.
11¹/₂ x 19³/₄ inches
(29.2 x 50.1 cm)

Signed lower left: Homer.

Collection Unknown.

(Not illustrated)

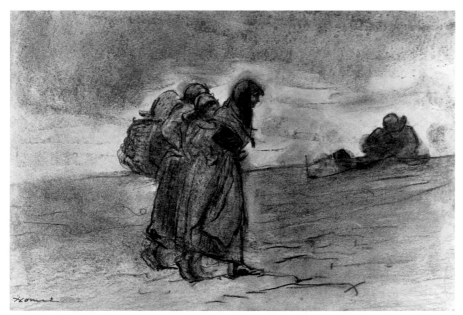

E91 "Fisherwomen" - 1882

Charcoal. 8¹/₂ x 12¹/₂ inches
(21.6 x 31.8 cm)

Signed lower left: Homer 1882

©*Metropolitan Museum of Art, New York*
Acc. No: X.249

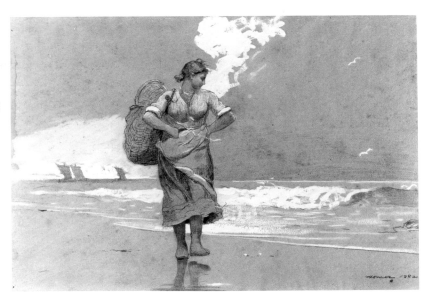

E92 "Drawing for *The Incoming Tide*" - 1882

Charcoal and chinese white

Signed lower right: Homer 1882.

Collection of Nicholas Wyeth, New York

This drawing, based on *The Incoming Tide (E93)*, was made by Homer for use in making a wood engraving for the catalogue of the Watercolor Society Exhibition in 1883.

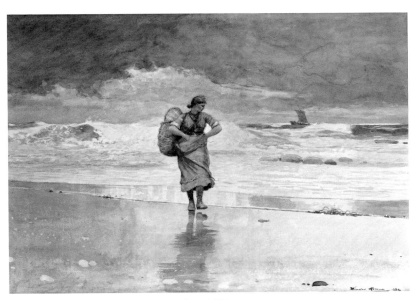

E93 "The Incoming Tide" - 1883

Watercolour. 21$\frac{1}{2}$ x 29$\frac{1}{2}$ inches (54.6 x 74.9 cm)

Signed lower right: Winslow Homer 1883.

©American Academy of Arts and Letters, New York.

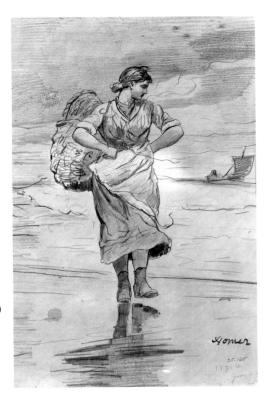

E94 "Fishergirl on the Beach" - 1883

Graphite. 14$\frac{3}{4}$ x 11$\frac{3}{8}$ inches (37.5 x 28.9 cm)

Signed lower right: Homer.

©Metropolitan Museum of Art, New York.
Acc. No: 25.165

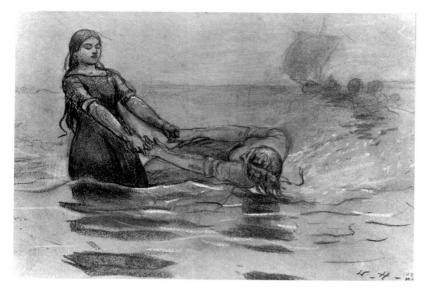

E95 "The Bathers" - 1882

Graphite and white chalk.
10 3/4 x 12 5/8 inches (27.3 x 32.0 cm)

Signed lower right: W.H.1882.

©Metropolitan Museum of Art, New York.
Acc. No: 20.113

E96 "Children Playing at the Seaside" - 1881-82

Charcoal on cream wove paper.
7 5/16 x 12 3/16 inches (18.5 x 31.0 cm)

©Cooper-Hewitt National Design Museum,
Smithsonian Institution, New York.
Gift of Charles Savage Homer Jr.
Acc. No: 1912.12.83
Photo: John Parnell.

This is Cullercoats Beach with Beacon Rock visible
as the backdrop. The children appear to be making
"sand-pies" with their mothers looking on. To their
left is the cliff that houses the "Pillar" cave.

E97 "Young Man Leaning Against a Rigging" - 1881-82

Graphite on gray wove paper.
7 3/16 x 4 7/16 inches (17.9 x 11.2 cm)

©Cooper-Hewitt National Design Museum,
Smithsonian Institution, New York.
Gift of Charles Savage Homer Jr.
Acc. No: 1912.12.116

E98 "Two Women Seated on a Sea
Wall" - 1881-82

Graphite and charcoal on cream
wove paper.
3^1/$_8$ x 6^{11}/$_{16}$ inches (7.9 x 17.0 cm)

*©Cooper-Hewitt
National Design Museum,
Smithsonian Institution, New York.
Gift of Charles Savage Homer Jr.
Acc. No: 1912.12.14*

E99 "Men and Women Looking Out to
Sea, Cullercoats, England" - 1881

Graphite on heavy cream wove paper.
6^9/$_{16}$ x 5^9/$_{16}$ inches (16.9 x 14.2 cm)

*©Cooper-Hewitt National Design Museum,
Smithsonian Institution, New York.
Gift of Charles Savage Homer Jr.
Acc. No: 1912.12.24 recto*

Cullercoats Beacon and Saddle Rocks

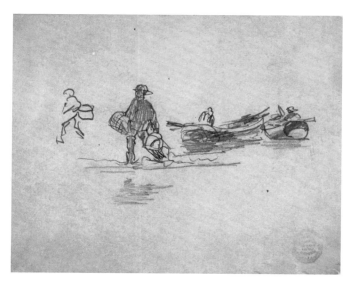

E100 "Fishermen's Dories and Two Men"
1881-82

Graphite on tan wove paper.
5 $^1/_8$ x 6 $^7/_{16}$ inches (13.0 x 16.3 cm)

©Cooper-Hewitt National Design Museum
Smithsonian Institution, New York.
Gift of Charles Savage Homer Jr.
Acc. No: 1912.12.220

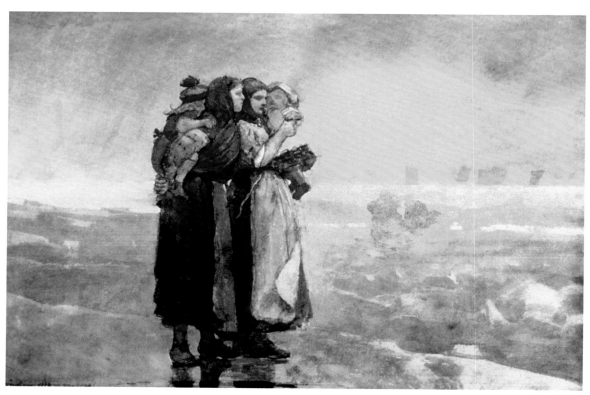

E101 "Forebodings" - 1881

Watercolour on paper. 14 $^1/_2$ x 21 $^1/_2$ inches
(36.8 x 52.0 cm)

Signed lower left: Winslow Homer 1881.

©Hyde Collection, Glens Falls, New York.
Acc. No: 1971.69

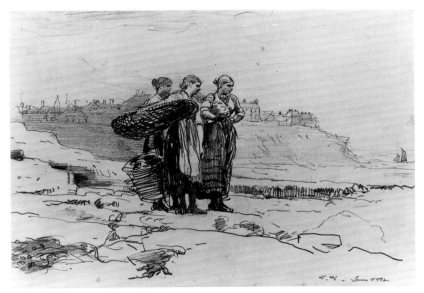

E102 "Fisher Girls" - June 1882

Graphite. 8¼ x 11¾ inches (21.0 x 29.8 cm)

Signed lower right: W.H. - June 1882.

©Carnegie Museum of Art,
Pittsburgh, Pennsylvania.

E103 "The Salmon Net"
(formerly "Figures on a Rock") - 1882

Charcoal and white chalk on paper.
21½ x 29¼ inches (54.6 x 74.3 cm)

Signed bottom left: Winslow Homer

©Seattle Art Museum,
Seattle, Washington.
William Idris Bequest Fund;
Margaret E. Fuller Purchase Fund;
Richard E. Fuller Acquisition Fund.
Acc. No: 74.67

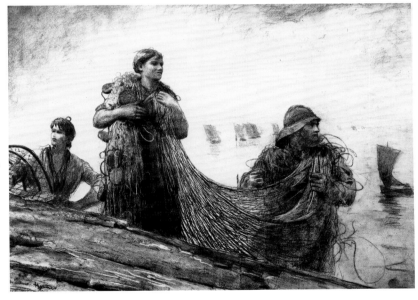

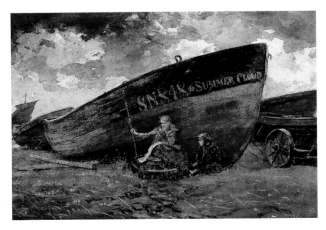

E104 "The Summer Cloud" - 1881

Watercolour.
13⁶/₁₆ x 19½ inches (34.0 x 49.5 cm)

Signed lower left: Winslow Homer 1881.

Private Collection.

Tynemouth, North Point

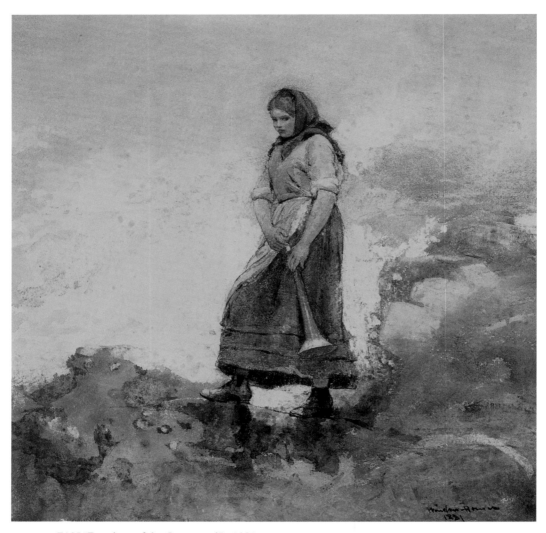

E105 "Daughter of the Coastguard" - 1881

Watercolour. 12¹/₂ x 13¹/₂ inches
(34.3 x 34.3 cm)

Signed lower right: Winslow Homer

© *Museo Thyssen-Bornemisza,*
Madrid, Spain.
Acc. No: 592

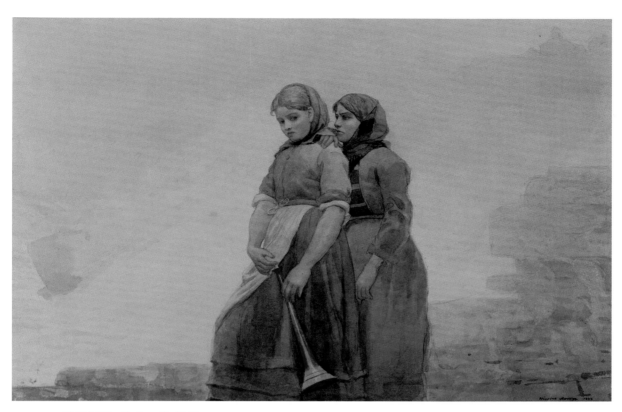

E105A "The Foghorn" - 1883

Watercolour. 13¼ x 20½
inches (33.6 x 52.7 cm)

Signed lower right:
Winslow Homer 1883

*Private Collection /
Bridgeman art Library*

E106 "Woman Looking out
to Sea" - 1881-82

Charcoal on white wove paper.
8⅞ x 7³⁄₁₆ inches (28.3 x 21.5 cm)

*©Cooper-Hewitt National Design Museum,
Smithsonian Institution, New York.
Gift of Charles Savage Homer Jr.
Acc. No: 1912.12.15*
Photo by John Parnell

Evidently a study for *The Lookout (E107).*

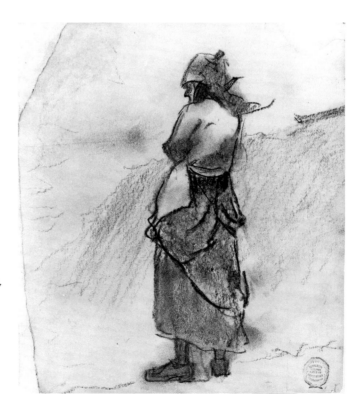

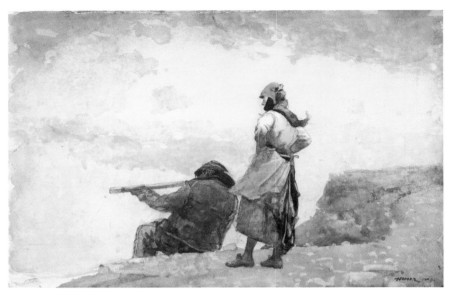

E107 "The Lookout" - 1882

Watercolour. 14¼ x 21¼ inches
(36.8 x 54.0 cm)

Signed lower right: Homer 1882.

©Fogg Art Museum,
Harvard University,
Cambridge, Massachusetts.
Anonymous gift.
Acc. No: 1939.0231.0000

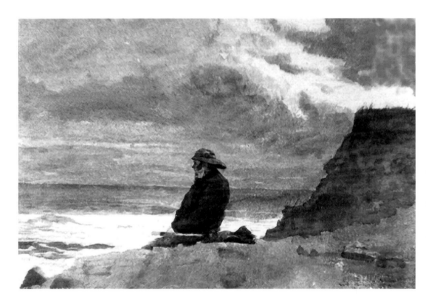

E108 "Above the Sea, Tynemouth"

Watercolour.

©Arkell Hall Foundation.
In the care of Canajoharie
Library and Art Gallery,
Canajoharie, New York.

E109 "Looking out to Sea,
Cullercoats" - 1882

Watercolour on paper. 13¾ x 20 inches
(34.9 x 50.8 cm)

Signed lower right:
Winslow Homer 1882.

Photo: Melville McLean

©Portland Museum of Art, Portland, Maine.
Bequest of Charles Shipman Payson.
Acc. No: 1988.55.17
Photo: Melville McLean

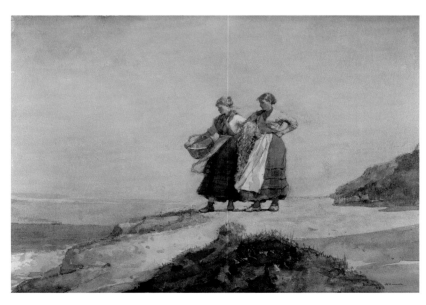

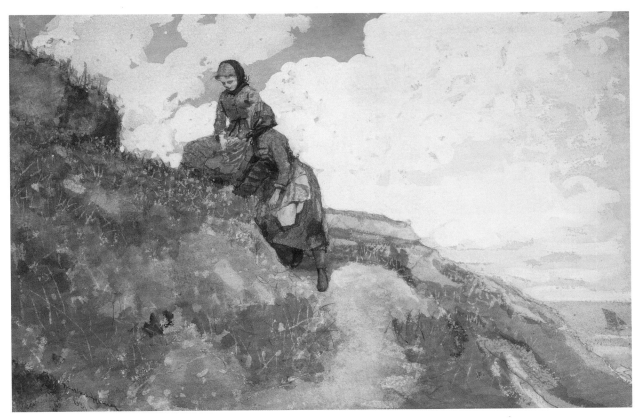

E110 "Girls on a Cliff" - 1881

Opaque and transparent watercolour.
12 ¹¹/₁₆ x 19 ¹/₈ inches
(32.2 x 48.5 cm)

Signed lower left:
Winslow Homer 1881.

© 2003 Museum of Fine Arts,
Boston, Massachusetts.
Bequest of David P. Kimball
in memory of his wife,
Clara Bertram Kimball.
Acc. No: 23.522

E111 "Fisherwomen"
1881-82

Black, gray-brown washes,
and white watercolour over
graphite pencil on paper
10 ¹/₄ x 14 ¹/₄ inches
(26.0 x 36.2 cm)

Signed upper right: Homer.

©2003 Museum of Fine Arts,
Boston, Massachusetts.
Bequest of John T. Spaulding.
Acc. No: 48.728

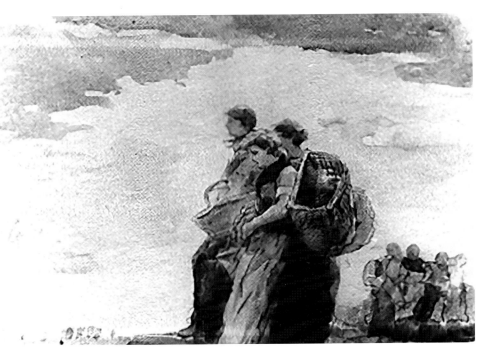

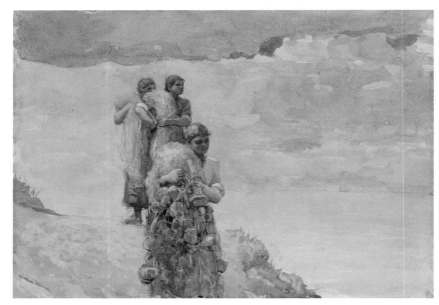

E112 "On the Cliff, Cullercoats" - c. 1881

Watercolour and graphite on wove paper.
14^{15}/$_{16}$ x 21^{1}/$_{8}$ inches
(37.6 x 53.6 cm)

Signed lower left:
Winslow Homer.

©Addison Gallery of American Art,
Phillips Academy,
Andover, Massachusetts.
Gift of anonymous donor.
Acc. No: 1930.15

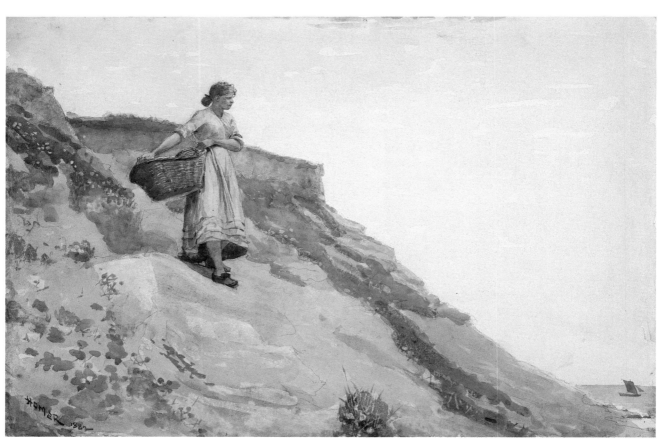

E113 "Girl Carrying a Basket" - 1881

Watercolour over graphite. 14^{5}/$_{8}$ x 21^{3}/$_{4}$ inches
(37.2 x 55.2 cm)

Signed lower left: Homer 1882.

©National Gallery of Art, Washington.
Gift of Ruth K. Henschel, in memory of her husband,
Charles R. Henschel.
Acc. No: 1975.92.4.(B-28397)/DR

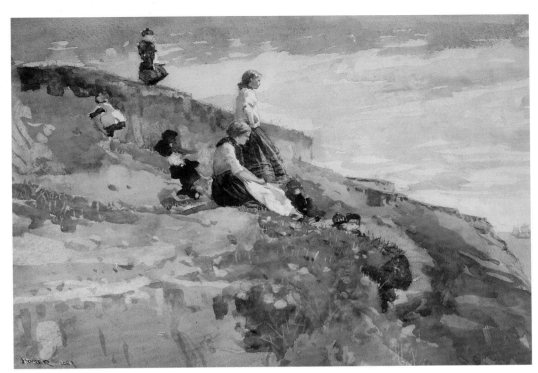

E114 "On the Cliff" - 1881

Watercolour.
13 1/2 x 19 1/8 inches
(34.3 x 48.5 cm)

Signed lower left:
Homer 1881.

©*Canajoharie Library
and Art Gallery,
Canajoharie, New York.*

E115 "Watching from the Cliffs" - 1881

Watercolour.

Private Collection.

(Not illustrated)

E116 "Two Fisherwomen" - 1884

Charcoal with white chalk on paper.
22 1/2 x 17 1/4 inches (57.2 x 43.8 cm)

©*Wadsworth Atheneum,
Hartford, Connecticut.
Gift of Mrs. James Lippincott Goodwin.
Acc. No: 1986.260*

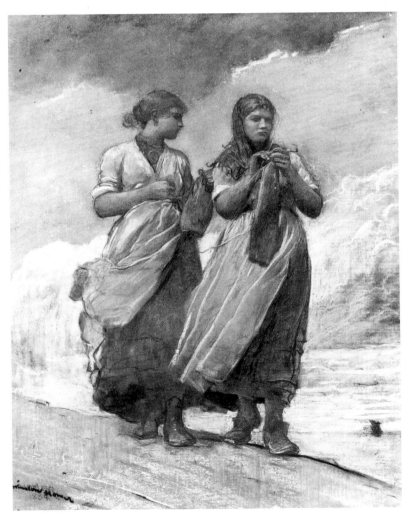

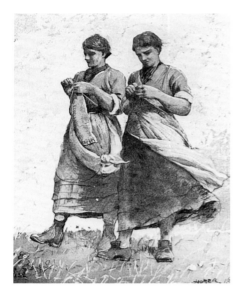

E117 "Enjoying the Breeze" - 1882/84

Charcoal and chalk. 14¼ x 10¾ inches (36.2 x 27.3 cm)

Signed lower left: Homer 1882 (overwritten: 1884)
Signed lower right: Homer 1884.

IBM *Art Collection, Armonk, New York.*

E118 "A Little More Yarn"
(formerly "Fishergirl Knitting") - 1884

Charcoal and white chalk on blue-gray
laid paper, mounted on cardboard.
17¾ x 23⅝ inches (45.1 x 60.0 cm)

Signed lower left: Winslow Homer 1884.

©*Fine Arts Museums of San Francisco,
San Francisco, California.
Gift of Mr. and Mrs. John D. Rockefeller III.
Acc. No: 1993.35.16*

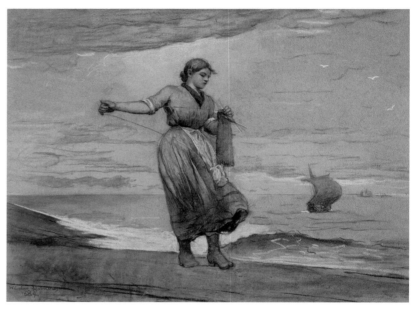

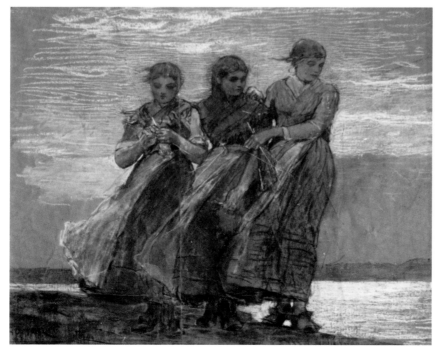

E119 "Three Girls" - 1881/82

Charcoal and white chalk.
17¼ x 20¼ inches (43.8 x 51.4 cm)

Private Collection

These three girls are also depicted
in *E120* and *E121*.

E120 "Early Evening" - 1881-1907

Oil on Canvas.
32⁷/₈ x 38¹/₄ inches (83.8 x 98.5 cm)

Signed lower centre: Homer.

*©Freer Gallery of Art,
Smithsonian Institution, Washington D.C.
Gift of Charles Lang Freer.
Acc. No: F1908.14*

This painting was commenced in Cullercoats,
(see *E121*), and then repainted in 1907.
It was bought by Charles L. Freer
for $5000 in January 1908.[4]

E121 "Sailors Take Warning
(Sunset)" - 1881

Photograph.

*©Freer Gallery of Art,
Smithsonian Institution,
Washington.
Acc. No: F1908.14*

This photograph is a compilation of the six X-radiographs
taken of *Early Evening (E120)*, following an investigation by
Michelle Mead to establish whether or not this was
originally Homer's *Sailors Take Warning (Sunset)* that had
not been seen since being exhibited at the World's
Columbian Exposition in 1893. The X-radiographs
confirmed that it was.[5]

The Long Sands, Tynemouth

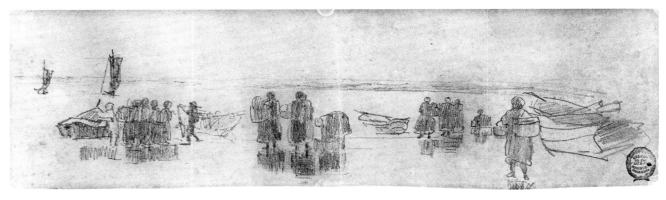

E122 "Beach with Four Fishing Boats, Cullercoats, England" - 1881-82

Graphite on gray-green wove paper.
3¹³/₁₆ x 13⁷/₁₆ inches (9.7 x 34.2 cm)

©Cooper-Hewitt National Design Museum, Smithsonian Institution, New York. Gift of Charles Savage Homer Jr. Acc. No: 1912.12.29
Photo: Scott Hyde

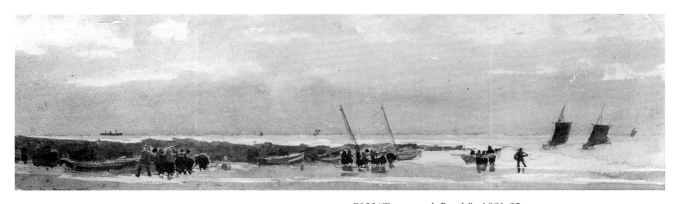

E123 "Tynemouth Beach" - 1881-82

Watercolour. 5¹/₄ x 18³/₄ inches (13.3 x 47.6 cm)

Collection Unknown.

E124 "View of Tynemouth Bay with Ruins of Tynemouth Priory in the Distance" - 1881

Charcoal, and white chalk on white wove paper.
13³/₈ x 21⁷/₈ inches
(34.0 x 55.6 cm)

©Cooper-Hewitt National Museum of Design, Smithsonian Institution, New York. Gift of Charles Savage Homer Jr. Acc. No: 1912.12.84

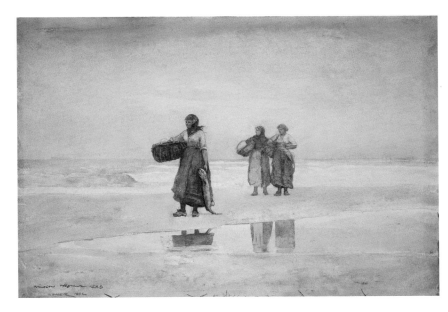

E125 "Tynemouth Sands" - 1882-83

Watercolour over graphite.
$14^{5}/_{8}$ x $21^{1}/_{2}$ inches
(37.2 x 54.6 cm)

Signed lower left: Homer 1882;
Winslow Homer 1883.

©*2003 Museum of Fine Arts,*
Boston, Massachusetts.
Bequest of Mrs. Arthur Croft.
Acc. No: 01.6232

The two signatures are something of a
mystery. Gordon Hendricks suggested
that the second signature was added when
Homer re-framed the painting.

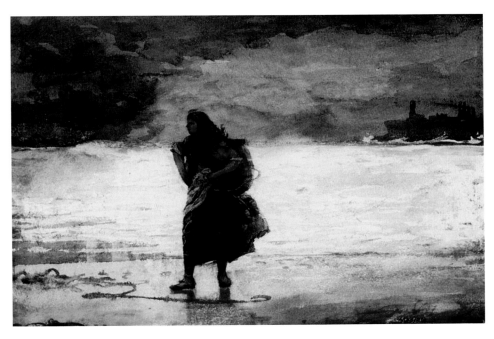

E126 "Fisherwoman, Tynemouth"
1881/82

Watercolour.
$14^{1}/_{2}$ x 21 inches (36.8 x 53.3 cm)

Private Collection.

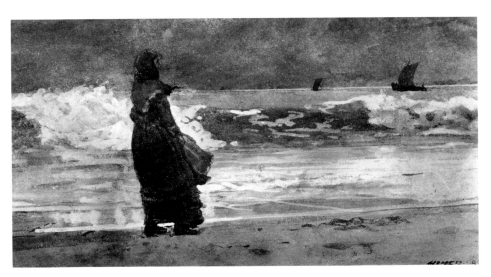

E127 "The Watcher,
Tynemouth" - c. 1882

Watercolour with white gouache
over graphite on cream wove paper.
$8^{3}/_{8}$ x $14^{3}/_{8}$ inches (21.2 x 37.7 cm)

Signed lower right: Homer 82.

©*Art Institute of Chicago, Chicago,*
Illinois. Mr. & Mrs. Martin A.
Ryerson Collection.
Acc. No: 1933.1255

Offshore Cullercoats

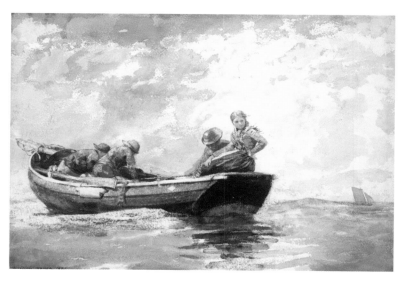

E128 "Fisher Folk in a Dory" - 1881

Watercolour.
13¼ x 19 inches (33.6 x 49.3 cm)

Signed lower left: Winslow Homer 1881.

©*Fogg Art Museum, Harvard University,*
Cambridge, Massachusetts. Anonymous gift.
Acc. No: 1939.0234.0000

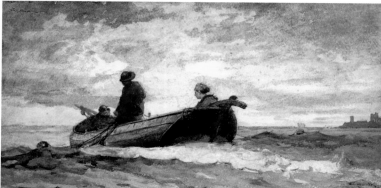

E129 "Tynemouth Priory, England"
(or "Hauling the Net, Tynemouth") - 1881

Watercolour with reddish-brown gouache
over graphite on ivory wove paper.
10¼ x 19⅞ inches (26.2 x 50.5 cm)

Signed lower right: Winslow Homer 1881.
Upper left: Tinemouth [sic] Priory
(Winslow Homer [N.A.?] England).

©*Art Institute of Chicago, Chicago, Illinois.*
Mr. and Mrs. Martin A. Ryerson Collection.
Acc. No: 1933.1254

E130 "An Afterglow"
(formerly "Boats off the
Devon Coast") - 1883

Watercolour over graphite
pencil on paper.
14¹⁵/₁₆ x 21⁹/₁₆ inches (38.0 x 54.7 cm)

Signed lower right: Homer 1883.

©*2003 Museum of Fine Arts,*
Boston, Massachusetts.
Bequest of William P. Blake
in memory of his mother,
Mary J. Dehon Blake.
Acc. No: 22.606

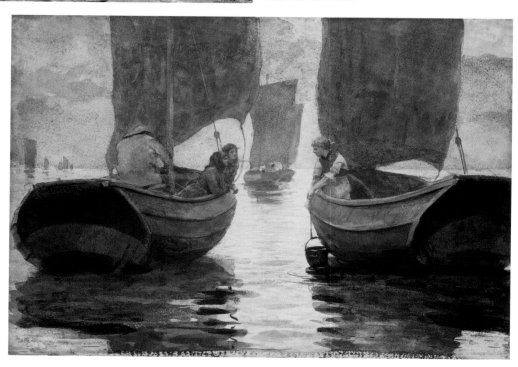

The former title of this painting
suggests that Homer visited Devon
while in England. Not only is there no
evidence to support this, but the
models and the coble are typical of
Cullercoats but not of Devon.

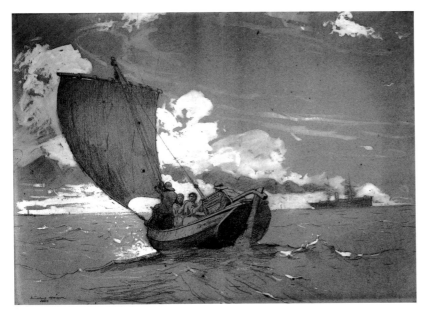

E131 "Fishing off Scarborough" - 1882

Graphite and white gouache on grayish-tan laid
paper with blue fibres.
18¼ x 24¼ inches (46.2 x 61.7 cm)

Signed lower left: Winslow Homer / 1882.

©Art Institute of Chicago, Chicago, Illinois.
Mr. and Mrs. Martin A. Ryerson Collection.
Acc. No: 1933.1239

It appears more likely that this coble is offshore
Cullercoats. The object on the left horizon could
be St. Mary's Lighthouse, just north of Cullercoats,
and the steam ship is likely to be heading for the river
Tyne. The boat's name *Yarmouth* perhaps
refers to its owners home port.

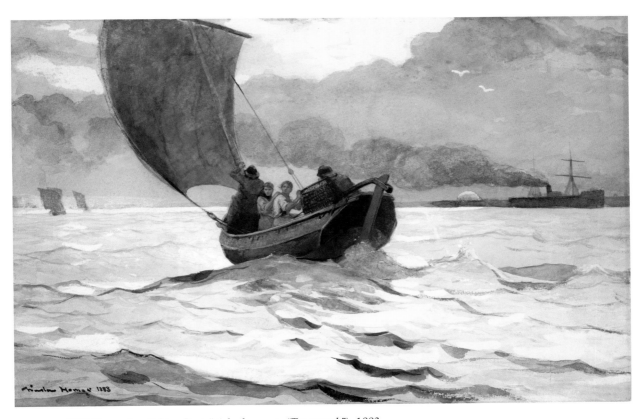

E132 "Returning Fishing Boats" *(also known as "Tynemouth")* - 1883

Watercolour and gouache.
15⅞ x 24¾ inches (40.3 x 62.9 cm)

Signed lower left: Winslow Homer 1883.

©Fogg Art Museum, Harvard University,
Cambridge, Massachusetts. Anonymous gift.
Acc. No: 1939.0233.0000

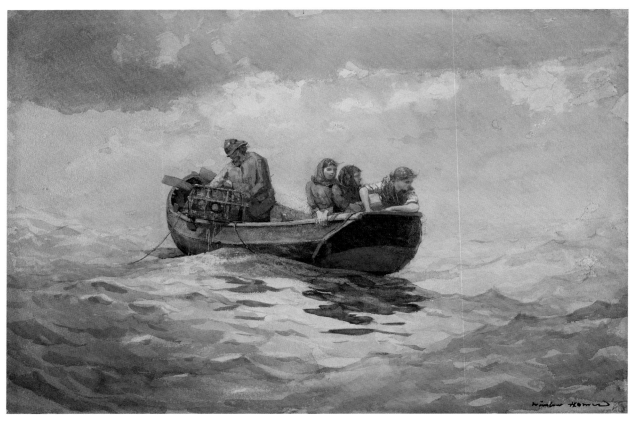

E133 "Crab Fishing off Yarmouth" - 1883

Watercolour. 14 x 20³/₄ inches (35.6 x 53.0 cm)

Signed lower right: Winslow Homer '83.

©Worcester Art Museum, Worcester, Massachusetts.
Bequest of Grenville H. Norcross.

E134 "Three Boats with Fishermen Setting a Net" 1881-82

Charcoal with brown ink on cream wove paper. 10¹¹/₁₆ x 19⁷/₁₆ inches (27.2 x 49.3 cm)

©Cooper-Hewitt National Design Museum, Smithsonian Institution, New York. Gift of Charles Savage Homer Jr. Acc. No: 1912.12.217

E135 "Seascape with Fishing Trawler, Cullercoats,
England" - 1881-82

Charcoal on cream wove paper.
7 1/8 x 12 3/8 inches (18.1 x 31.5 cm)

©Cooper-Hewitt National Design Museum,
Smithsonian Institution, New York.
Gift of Charles Savage Homer Jr.
Acc. No: 1912.12.31
Photo: Scott Hyde

E136 "Fishing Trawler" - 1881

Charcoal on cream wove paper.
7 3/8 x 12 15/16 inches (18.8 x 31.3)

©Cooper-Hewitt National Design Museum,
Smithsonian Institution, New York.
Gift of Charles Savage Homer Jr.
Acc. No: 1912.12.255

Section O

Tynemouth Haven

E137 "First Sketch for *Wreck
of the Iron Crown*" - 1881

Charcoal on cream wove paper.
6 5/8 x 9 5/8 inches (16.9 x 24.4 cm)

©Cooper-Hewitt National Design
Museum, Smithsonian Institution,
New York.
Gift of Charles Savage Homer Jr.
Acc. No: 1912.12.215
Photo: Ken Pelka

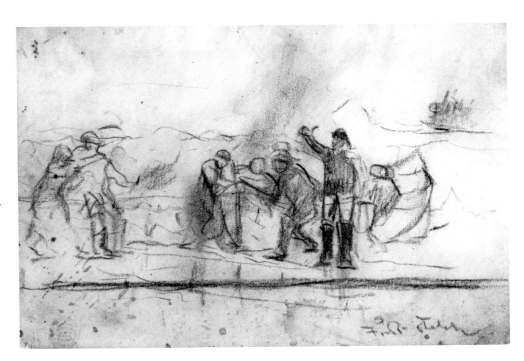

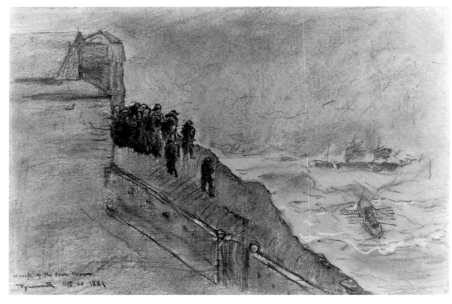

E137A "Study for The Wreck of the Iron Crown" - 1881

Charcoal with white chalk.
8¹⁄₂ x 12¹⁄₂ inches
(21.5 x 31.9 cm)

Inscribed lower left:
Wreck of the *Iron Crown*,
Tynemouth October 28 1881.

Collection of Carleton Mitchell.
On extended loan to
Baltimore Museum of Art.

This was sketched at around 11 am on Saturday 22nd October 1881, when the Tynemouth Lifeboat was relaunched to rescue the remaining crewman who had been left on board following first rescue operation during the early hours of the morning. The artist George Horton witnessed Homer producing the sketch.

E138 "The Wreck of The Iron Crown" - 1881

Watercolour. 20¹⁄₄ x 29³⁄₈ inches
(51.4 x 74.6 cm)

Signed lower left: Winslow Homer 1881.

Collection of Carleton Mitchell.
On extended loan to Baltimore Museum of Art.

The rigging in Homer's painting of The *Iron Crown* is remarkably intact, considering that the wreck occurred some 10 hours before he saw it, and that during that time it had been buffetted and pounded by heavy seas while marooned on the Black Midden rocks. As this seems to be a studio painting compiled from memory and at least one "on the spot" drawing *(E137A)*, it is possible that Homer took a good deal of artistic licence.

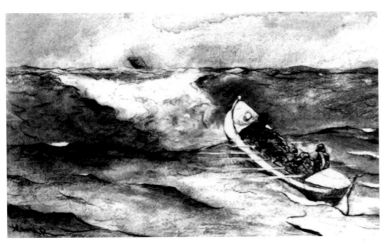

E139 "The Life Boat" *(Study for "The Wreck of the Iron Crown")* - 1881

Point of brush and black chalk,
black wash with white gouache
on heavy off-white wove paper.
13 $^{15}/_{16}$ x 19 $^1/_{16}$ inches (35.4 x 48.4 cm)

Signed lower left: Homer.

©*Cooper-Hewitt National Design Museum,
Smithsonian Institution, New York.
Gift of Charles Savage Homer Jr.
Acc. No: 1912.12.130*

Despite the title of this sketch, it may not be directly related to the Iron Crown shipwreck. The vessel on the horizon appears to be a single masted coble, not a three masted iron barque, and the location would appear to be offshore rather than in the mouth of the river Tyne. The Tynemouth Lifeboat had a crew of twelve, consisting of the Coxwain, the 1st mate, and the ten oarsmen (5 on each side). In this sketch Homer has 5 oarsmen and 6 oars on the port side.

Section P
Flamborough Head and Bridlington

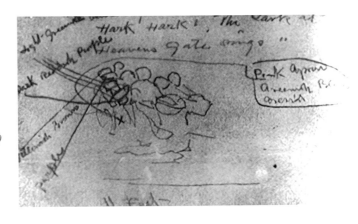

E140 "Sketch for *Hark! The Lark*" - 1881-82

Drawing. 3 $^5/_8$ x 5 $^1/_2$ inches (9.2 x 14.0 cm)

Formerly collection of Lois Homer Graham.

Although this sketch and the resultant painting *(E142)* are referred to as *Hark! The Lark*, Homer intended them to be titled *Hark! Hark! The Lark*. "Hark! Hark! The Lark at Heaven's gate sings" is in Act II Scene 11 of Shakespeare's Cymbeline.

E141 "Sketch for *Hark! The Lark*" - 1882

Graphite on off-white wove paper.
13 $^1/_2$ x 13 $^1/_2$ inches (34.4 x 34.4 cm)

©*Art Institute of Chicago, Chicago, Illinois.
Mr. and Mrs. Martin A. Ryerson Collection.
Acc. No: 1933.1251 verso*

This is on the reverse of Homer's *The Return, Tynemouth (E78)*

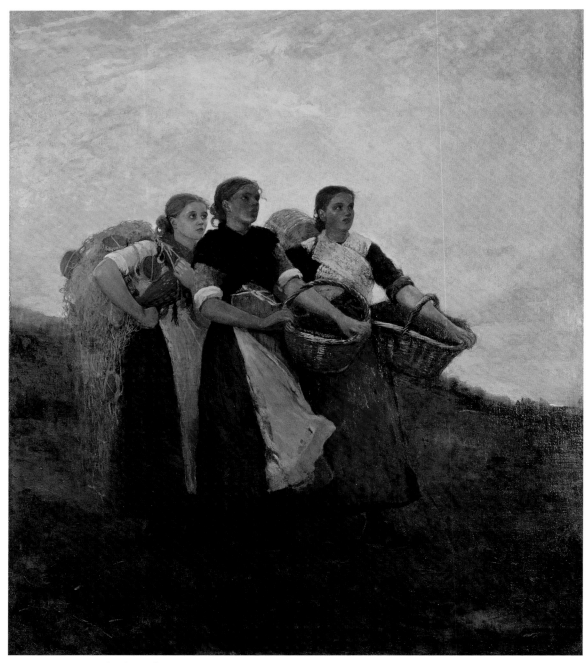

E142 "Hark! The Lark" - 1882

Oil on Canvas. 36 ³/₈ x 31³/₈ inches (92.4 x 79.9 cm)

Signed lower right: Winslow Homer 1882.

©Milwaukee Art Museum, Layton Art Collection,
Milwaukee, Wisconsin.
Gift of Frederick Layton.
Acc. No: L99

Perhaps the title is an allusion to early morning? The lark is
an "early bird"; the song *Hark! Hark! The Lark* was sung to
Imogen in Shakespeare's Cymbeline in order to waken her
from her slumbers, and of course the Cullercoats fisherlasses
are awaiting the early morning return of the fishing cobles.

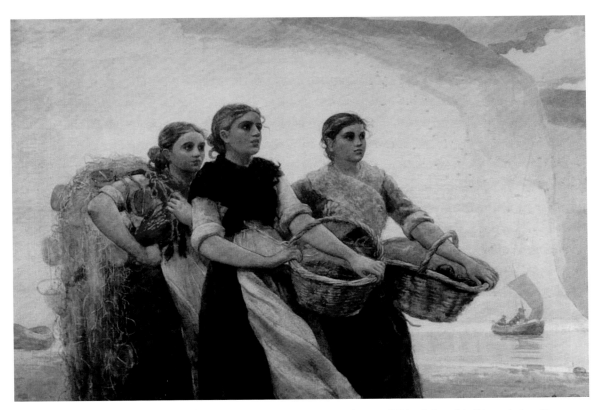

E143 "A Voice from the Cliffs" - 1882

Watercolour. 20 ⁷⁄₈ x 29 ³⁄₄ inches
(53.0 x 75.6 cm)

Private Collection.

In a letter to O'Brien & Sons, his Chicago dealers, Homer says of this painting, "Only once in thirty years have I made a duplicate, and that was a watercolor from my oil picture now owned by the Layton Art Gallery Milwaukee, called *Hark, the Lark*. It is the most important picture I ever painted and the very best one, as the figures are large enough to have some expression on their faces. The watercolor was called *A Voice from the Cliffs* and well known."

E144 "A Voice from the Cliffs" - 1888

Etching. 19³⁄₈ x 30¹⁄₄ inches (49.2 x 76.8 cm)

©*Metropolitan Museum of Art, New York.*
Acc. No: 66.516

E145 "Listening to The Voice from the Cliffs"

Wood Engraving.

©*Strong Museum, Rochester, New York.*

(Not illustrated)

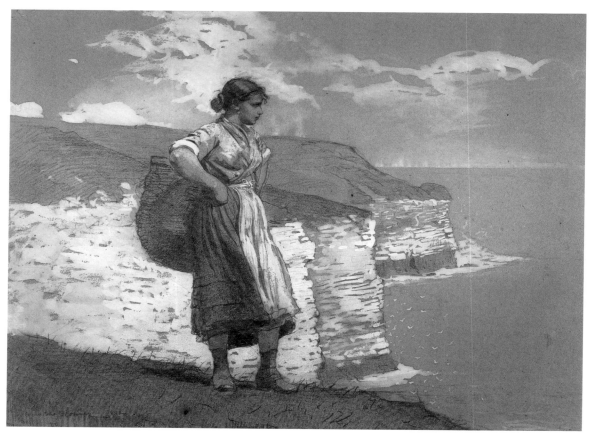

E146 "Flamborough Head" - 1882

Graphite with white gouache
on grayish-tan laid paper with
blue fibres.
17³/₄ x 24 inches (44.4 x 61.0 cm)

Signed lower left:
Winslow Homer 1882,
Flamborough Head.

©Art Institute of Chicago,
Chicago, Illinois.
Mr. and Mrs. Martin
A. Ryerson Collection.
Acc. No: 1933.1240

The model is Maggie Storey. Since it is unlikely
that she travelled to Flamborough Head with
Homer, he probably executed the background
there and appended Maggie in his Cullercoats studio.

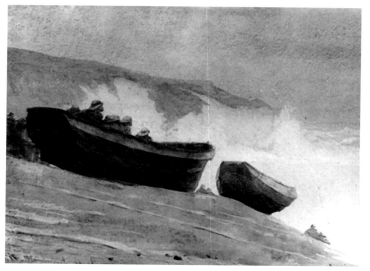

E147 "Storm on the English Coast"
1881-82

Watercolour.

Private Collection.

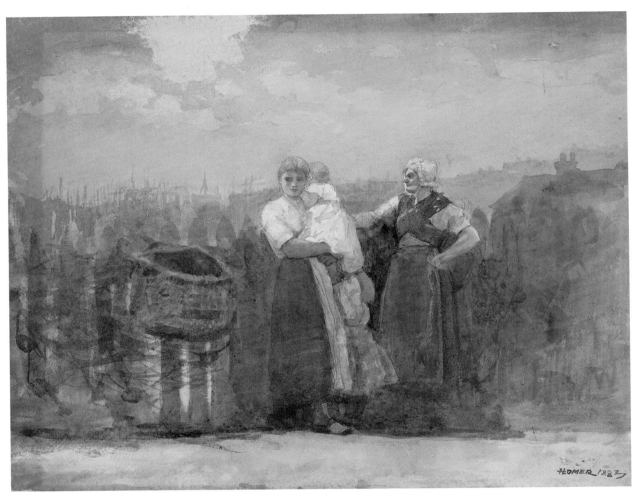

E148 "Bridlington Quay" - 1883

Watercolour over graphite.
12½ x 15½ inches
(31.8 x 39.4 cm)

Signed lower right: Homer 1883.

©2003 Museum of Fine Arts,
Boston, Massachusetts.
Bequest of Ralph W. Gray
in memory of his father,
Samuel S. Gray.
Acc. No: 44.681

Bridlington is a fishing port in Yorkshire,
just south of Flamborough Head.

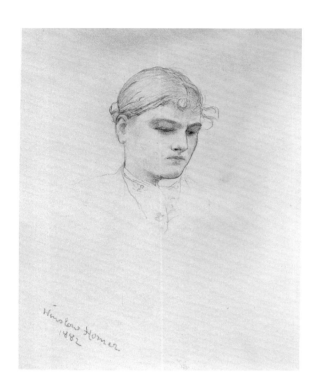

E149 "Head of a Woman"

Graphite. 6 x 7 ¹/₂ inches (15.2 x 19.1 cm)

Collection unknown.

This is probably a sketch of Homer's favourite Cullercoats model, Maggie Storey.

E149A "Portrait of Ralph Brunton"

Studio Gallery of Art
Detroit, MI

(Not illustrated)

E150 "Coursing the Hare" - c. 1883

Oil On Canvas.
14 ⁷/₈ x 27 ¹/₂ inches (38.0 x 70.0 cm)

© Virginia Museum of Fine Arts,
Richmond, Virginia.
The Paul Mellon Collection.
Acc. No: 85.642
Photo: Katherine Wetzel

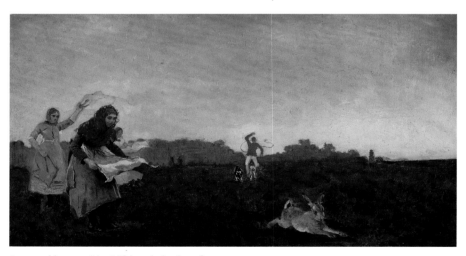

A most odd composition! Although the three figures on the left are Cullercoats fisherlasses, the man in the centre, the venue, and the subject are alien to the area. There is no evidence to suggest that hare coursing was ever a common sport in Cullercoats.

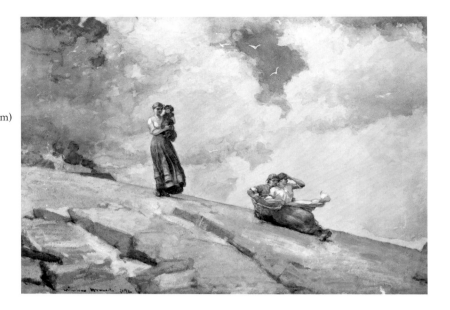

E151 "Watching from the Cliffs" - 1892

Watercolour. 14 x 20 inches (35.6 x 50.8 cm)

Signed lower left: Winslow Homer 1892

©*Carnegie Museum of Art,*
Pittsburgh, Pennsylvania.

The setting is High Cliff, Prout's Neck.
Inspiration for this work came from
Homer's Cullercoats paintings -
On the Cliff (E114) and
Watching from the Cliffs (E115).[6]

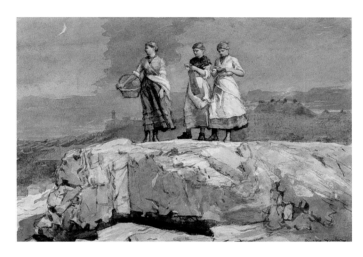

E151A "Where are the Boats" - 1883

Watercolour. 13 x 19 inches
(33.0 x 48.2 cm)

Private Collection

E151B "The Faggot Gatherer, Tynemouth" - 1883

Watercolour. 14 x 20 inches
(35.6 x 51.4 cm)

Signed lower left: Winslow Homer / 1883

Christie's Images, London / Bridgeman Art Library

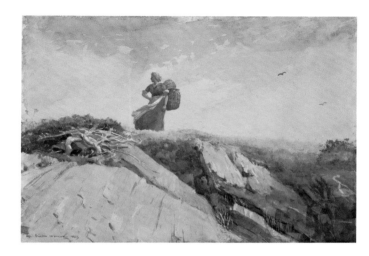

E151C "Down the Cliff" - 1883

Watercolour, gouache and pencil.
14$\frac{1}{8}$ x 19$\frac{3}{4}$ inches (35.6 x 50.6 cm)

Private Collection / Bridgeman Art Library

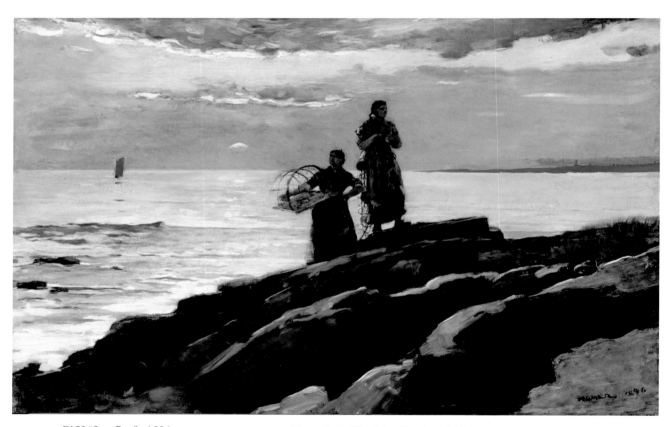

E152 "Saco Bay" - 1896

Oil On Canvas. 23$\frac{13}{16}$ x 37$\frac{15}{16}$ inches
(60.5 x 96.4 cm)

Signed lower right: Homer 1896.

©*Sterling and Francine Clark Art Institute,
Williamstown, Massachusetts.
Acc. No: 1955.5*

The setting is West Point, Saco Bay, which separates
Prout's Neck from the mainland to the south. The
fisherlasses and the coble are obviously of Cullercoats
origin, but Homer used two local girls, Sadie Sylvester
and Cora Sanborn, as the models .[7]

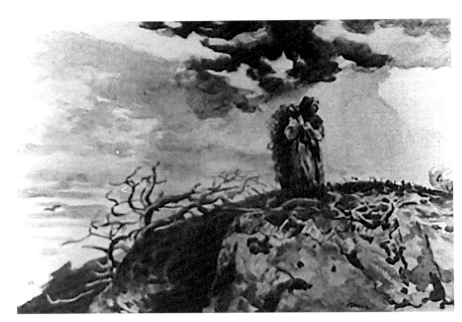

E153 "The Fisher Girl"

Watercolour. 15 x 21$\frac{1}{8}$ inches (38.1 x 53.7 cm)

Signed lower right: Homer.

©*Cincinnati Art Museum, Cincinnati, Ohio.*
Bequest of Mary Hanna. Acc. No: 1956.97

The setting would appear to be Prout's Neck,
and although the fishergirl has Cullercoats origins,
the model was probably a local girl.

E154 "The Fisher Girl" - 1894

Watercolour.

©*Mead Art Museum,*
Amherst, Massachusetts.

This painting was inspired by
Homer's Cullercoats sojourn with
the fisherlass draped in typical
Cullercoats costume. The model was
Ida Meserve, one of several local girls
that Homer employed at Prout's Neck.

(Not illustrated)

E155 "Shepherd" - 1882

Watercolour.
12$\frac{1}{4}$ x 18$\frac{3}{4}$ inches (31.1 x 47.7 cm)

Private Collection

(Not illustrated)

TEXT NOTES

1. For a detailed discourse and interesting anecdotes on the North Shields steam trawler fleet, see:-Ron Wright - *Beyond the Piers*, Cullercoats 2002

2. William Weaver Tomlinson - *Historical Notes on Cullercoats, Whitley and Monkseaton*, Newcastle upon Tyne 1893.

3. For further information on these and many other North East artists who found inspiration in Cullercoats see:- Marshall Hall - *The Artists of Northumbria*, Newcastle upon Tyne 1982. Ray Layton - *When Cullercoats was an Artists Colony*, North Magazine, October 1974. John Millard - *North East Artists on the Coast*, Winslow Homer: All the Cullercoats Pictures, Northern Centre for Contemporary Art, Sunderland 1988

4. *Newcastle Courant* - 26 August 1881.

5. *Tyneside Daily Echo* - 31 August 1881.

6. *New York Times* - Thursday 17 March 1881. The *New York Times* of 15 March 1881 contained an advertisement from Cunard Line stating that the 'Parthia' was to sail at 5.30 a.m. on Wednesday 16 March 1881.

7. Robert J. Demarest - *Traveling with Winslow Homer: America's Premier Artist / Angler*, New York 2002

8. *Liverpool Daily Post* - Tuesday 29 March 1881.

9. Tomlinson - *Historical Notes on Cullercoats, Whitley and Monkseaton.*

10. William Howe Downes - *The Life and Works of Winslow Homer* - Boston 1911.

11. Helen A.Cooper - *Winslow Homer Watercolors*, Washington 1986

12. Downes - p251. Letter to Downes from Homer: August 1908.

13. Kay Jenner - *Script for Intended Talk*, Monkseaton 1956.

14. Jenner - *Script for Intended Talk*

15. Ron Wright - *Cullercoats*, Cullercoats 2002

16. David Tatham - *Winslow Homer's Library*, American Art Journal, Vol 9, No 1, May 1977.

17. For a discourse on Homer and photography see:- Naomi Rosenblum - *The Influence of Photography on the Paintings of Homer and Eakins*, January, 1974

18. George Horton - *Artist with a Craze for Clocks*, The Sunday Sun, 5 March 1939

19. Jenner - *Script for Intended Talk*

20. Quoted by Cooper - *Winslow Homer Watercolors*, p 90

21. For further information on Lord Armstong and Cragside see:- Peter McKenzie - *W.G.Armstrong: A Biography*, 1983

22. Lloyd Goodrich - *Winslow Homer*, New York 1944

23. Philip C.Beam - *Winslow Homer Watercolors*, Bowdoin College Museum of Art Exhibition Catalogue 1983

24. *Art Interchange* - 7, 1 September 1881, p 38

25. Four letters written by Homer to J.Eastman Chase from Cullercoats now in the Archives of American Art.

26. Tatham - *Winslow Homer's Library*

27. Jenner - *Script for Intended Talk*

28. For further information on the Tyne Lifeboats and Volunteer Life Brigade, see:- William S. Garson - *The Origins of the Tyne Lifeboats*, 1929

29. For further information on Robert Smith see:- Alexander Rocca - *Ready, Aye Ready*, The Beacon, June and July 1981

30. Gordon Hendricks - *The Life and Works of Winslow Homer*, New York 1979

31. *Other reports of the wreck of the Iron Crown conflict with the Shields Gazette in regard to the number of men inadvertently left on board ship following the first rescue attempt. All other reports state that only one man was left on board, and this is also stated in the record of the rescue in the files of the Tynemouth Volunteer Life Brigade. Interestingly enough, Homer depicts only one man onboard the Iron Crown in his painting of the shipwreck*

32. William H.Gerdts - *Winslow Homer in Cullercoats*, Yale University Art Gallery Bulletin, Spring 1977

33. Horton - *Artist with a Craze for Clocks*

34. For further information on Frank Meadow Sutcliffe see:-Michael Hiley - *Frank Sutcliffe, Photographer of Whitby*, 1974

35. For a discourse on the similarities between Homer's and du Maurier's illustrations see:- John Wilmerding - *Winslow Homer's English Period*, American Art Journal, vol VII No 2 November 1975

36. *Liverpool Daily Post* - Monday 13 November 1882

37. *New York Times* - Friday 24 November 1882

CATALOGUE NOTES

1. "Mending the Tears" is one of three etchings of English subjects produced by Homer in 1888. The others are "Perils of the Sea" *(E26)* and "A Voice from the Cliffs" *(E144)*.

2. Helen A. Cooper, *Winslow Homer Watercolors* (Washington: 1986).

3. For more information on Winslow Homer's etchings see: David Tatham, *Winslow Homer in the 1880's* (Syracuse: Everson Museum of Art Exhibition Catalogue, 1983).

4. In a letter to Homer dated November 19 1907 regarding the framing of this work, the New York dealers M. Knoedler & Co., refer to this painting as "Early Morning". Homer's reply was written on Knoedler's letter, and he altered the title from "Early Morning" to "Early Evening" stating that "this is the title to that picture that I have ordered a frame for." See this and other correspondence on the sale of the painting in Winslow Homer in Monochrome (M. Knoedler & Co., 1986).

 The title of this work, "Early Evening", and its previous title before repainting, "Sailors Take Warning (Sunset)", *(see E121)*, are intrigueing. Cullercoats is on the North East Coast of England, and having lived in the village for 18 years, I know that it is impossible to see the sun set over the sea. I have seen and photographed many superb sunrises over the sea, but no sunsets! The original title of "Sailors Take Warning" presumably comes from the old saying, "Red Sky at Night, Shepherds Delight; Grey Sky in Morning, Sailors Take Warning." But why the painting apparently had the title of Sunset at one time is unclear. The title of "Early Morning" in the Knoedler letter would seem to be the most appropriate for the work.

5. Michelle Mead, *Giving Up His Ghost: The Finding of Homer's Sailors Take Warning (Sunset)*, American Art, Volume 7, Number 2, Spring 1993. And correspondence with Linda Merrill, Curator of American Art, Freer Gallery of Art, Smithsonian Institution, Washington.

6. For a discourse on this and several other of Homer's later works inspired by his visit to Cullercoats see: Philip C. Beam, *Exhibition Checklist, Winslow Homer in the 1890's*, (Rochester: 1990).

7. Philip C. Beam, *Exhibition Checklist, Winslow Homer in the 1890's* (Rochester: 1990). Beam comments that Cora Sanborn, one of the models that Homer employed for the painting, bore a striking resemblance to Homer's favourite Cullercoats model, Maggie Storey.

PHOTOGRAPH CREDITS

Figs 1, 69, 70, 79, 80, 87, 88, 92, 93, 94, 95. Peter R. Hornby

Figs 2, 56, 68, 83. Bowdoin College Museum of Art

Fig 4. Sterling and Francine Clark Art Institute

Fig 10. Hirschl & Adler Galleries

Fig 14. Milwaukee Art Museum

Fig 18. Yale University Art Gallery

Figs 20, 52, 53. Anne Pexton

Fig 22. Sotheby's, London

Figs 23, 25, 40. Tyne & Wear Museums

Fig 28. Westminster City Libraries

Figs 29, 30. Newcastle upon Tyne City Library

Fig 31. Addison Gallery of American Art

Figs 36, 76, 82. North Shields Central Library

Figs 41, 42. John Boon

Figs 47, 86, 89, 90, 91. Ron Wright

Fig 50. May Thorrington

Fig 51. Art Institute of Chicago

Figs 54, 63. Worcester Art Museum

Fig 55. The Strong Museum

Fig. 57. National Gallery of Art, Washington

Figs 71, 77. Baltimore Museum of Art

Figs 73, 78. Tynemouth Volunteer Life Brigade

Fig 74. Cooper-Hewitt National Museum of Design

Fig 84. Museum of Fine Arts, Boston

Figs 11, 24, 44, 62, 79. Private Collectors

Figs 6, 26, 27, 34, 35, 81, 83. The author

All catalogue pictures courtesy of the Galleries, Museums and Private Collectors credited

All other text photographs from the collection of the author

ACKNOWLEDGEMENTS

The preparation of this book has been a labour of love. My first words were committed to paper way back in 1981, shortly after the Winslow Homer Cullercoats Centenary Exhibition had finished. Since then I have been in contact with numerous individuals and institutions over the years, who have helped in both large and small ways to bring this project to fruition.

Three people deserve a special mention. Firstly John Boon. I came into contact with John in 1979 when, as Founder and Secretary of Cullercoats Local History Society, and Editor of the *Beacon* magazine, I was undertaking some research for a series of articles on artists who had found inspiration in Cullercoats. I knew little of Winslow Homer at that time, but John's amazing energy and enthusiasm for Homer rubbed off on me, resulting in my proposal to stage the 1981 exhibition. We became good friends, and John's help and support in putting together the exhibition, and subsequent support for the book was second to none. I was always welcomed on visits to his home, both by John and his wife Mollie, and spent many a lively session discussing Homer. Sadly John died in December 1990, just three weeks before his 93rd birthday, Mollie having died in 1988. They are both sadly missed by me, but will always be fondly remembered. I hope that this book will serve in some small way to ensure that they are never forgotten.

In April 1983, I wrote to David Tatham at Syracuse University, telling him of my work on Homer. I received an enthusiastic response, and correspondence followed. We first met each other in a hospital ward, in the late summer of 1984, when David and his wife Cleota were in London. Unfortunately, David had had a minor argument with a motor car when crossing a London street, ending up in hospital for a few days. David and Cleota subsequently visited us in Cullercoats in November 1984, and we had a pleasant day revisiting some of the locations where Homer had painted, and had lunch in the Bay Hotel where Homer had lodged during his visit to Cullercoats. David became very supportive of my work and has helped in many ways, not least in copy-editing my original manuscript in 1985/86, and contributing an introduction to this book. I am most grateful for his scholarly help and support.

My grateful thanks go to Peter Hornby, my publisher. His support, encouragement and fresh thinking on the presentation, revision and enlargement of my original manuscript has been inspirational. Acting as his assistant during his recent visit to the South East of Scotland to photograph lighthouses, was educational, eye-opening and a very enjoyable experience.

The following individuals and organisations have all been very helpful in many different ways. I have listed their names in alphabetical order for convenience of reference, rather than in order relevant to the importance of their help or assistance:

Susan Alpert, Cunard Line; Marion Angus; Linda Ayres, National Gallery of Art; Charles Brock, National Gallery of Art; Tammy Clarke; Henry Collis; Helen Cooper, Yale University Art Gallery; Wayne Craven, University of Delaware; Melissa De Medeiros, M. Knoedler & Co.; Michelle Mead Dekker; Bob Demarest; Andy Dobbins; William B. Gerdts; Lois Homer Graham; Linda Greenley; Alex Hastie, Tynemouth Volunteer Life Brigade; Rose Harrison; Marjorie Hill, Westfield Girls School, Oakfield House; Eric Hollerton, North Shields Central Library; Ray Layton; William McNaught, Archives of American Art; Linda Merrill, Freer Gallery of Art; John Millard, Laing Art Gallery; M.P. Naud, Hirschl and Adler Galleries; Constance Overesch; Anne Pexton; Sue Welsh Reed, Museum of Fine Arts, Boston; R.S. Reis, Public Records Office; Bruce Robinson, Eastern Daily Press; Naomi Rosenblum; Jennifer Saville, Honolulu Academy of Arts; John J. Saulle, Barridoff Galleries; Bill Eglon Shaw, The Sutcliffe Gallery; Cud Simpson; Vi Stocks; Miss M.J. Swarbrick, Westminster City Libraries; H.D. Taylor, H.M. Immigration Office; May Thorrington; Meta Viles, Royal Scottish Academy; Ron Wright.

In addition I must gratefully thank all the Institutions and Private Collectors who gave permission for their works to be reproduced in this book. Without their support, the Catalogue of Homer's English Works would certainly have been the poorer.

Finally my thanks are due to my daughter Gillian, who, assisted by my daughter Laura, typed my manuscript into the word processor, and to my wife Margaret and son Iain, for their patience and forbearance, in allowing me to devote so much time to this project.

Tony Harrison